IMAGES
of America

BERKELEY HEIGHTS
REVISITED

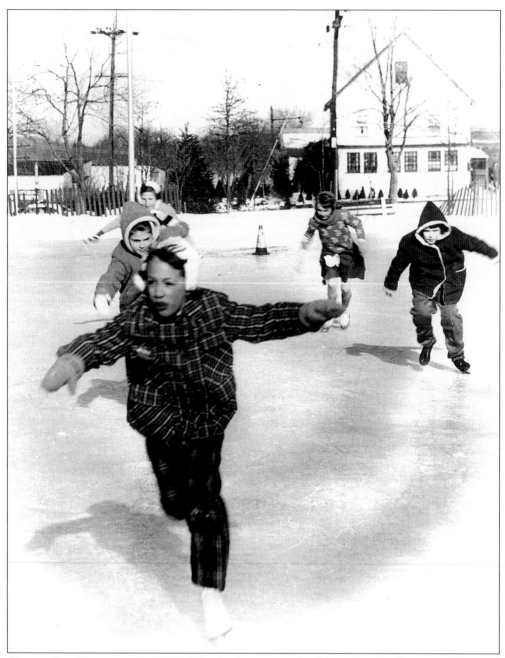

ON THE ICE, FEBRUARY 3, 1963. The day is sunny and cold, perfect for skating at Memorial Field off Plainfield Avenue. (Columbia School.)

COVER PHOTOGRAPH: TESTING THE WATERS, C. 1980. Township youngsters enjoy a spring day at the Littell-Lord Farmstead pond on Horseshoe Road. The dock has since been removed. (Berkeley Heights Historical Society.)

IMAGES
of America

BERKELEY HEIGHTS
REVISITED

Virginia B. Troeger

ARCADIA

First published 2005

Published by Arcadia Publishing,
Charleston SC, Chicago IL, Portsmouth NH, San Francisco CA

Printed in Great Britain

Library of Congress Catalog Card Number: 2004115330

For all general information, contact Arcadia Publishing:
Telephone 843-853-2070
Fax 843-853-0044
E-mail sales@arcadiapublishing.com
For customer service and orders:
Toll-free 1-888-313-2665

Visit us on the Internet at www.arcadiapublishing.com

To Ruffles.

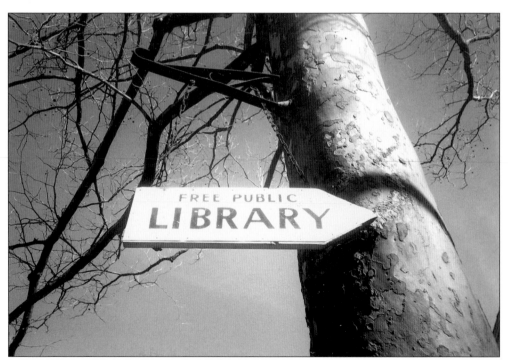

IN THE RIGHT DIRECTION, C. 1996. This sign in front of the Berkeley Heights Free Public Library points the way for library patrons. (Joan L. Rotondi.)

CONTENTS

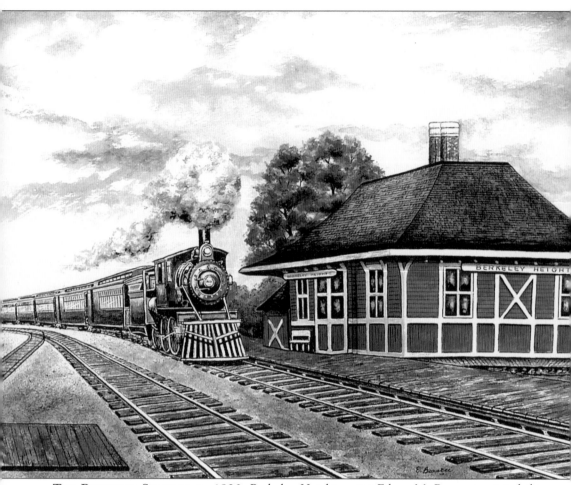

THE RAILROAD STATION, C. 1920. Berkeley Heights artist Eileen M. Bonacci painted this watercolor in 2001. Her original is displayed at the Station House Café, at 128 Station Street in Berkeley Heights.

ACKNOWLEDGMENTS

My name may be on the cover, but without the help of many others, this book would not have become a reality. Listed here in alphabetical order, these folks and organizations lent photographs, answered questions, and offered support: Don Bender, Dolores and Bill Benson, Berkeley Heights Historical Society, Berkeley Heights Public Library, Eileen M. Bonacci, Anne Bosefskie, David Bosefskie, Dave Christie, Art Conk, Terrence D. Conner, Betsy Dalrymple, Donald DeFabio, Jeff Diamond, Julia Donnelly, Mary Ellen Ericksen, Carolyn Farnsworth, Laura Fuhro, Lawrence Fuhro, Fred Gizzi, Kay Grant, Cynthia Troeger Gullikson, Laurel and Sigmar Hessing, Carol Imbimbo, Alice and Fred Keimel, Don Knowles, Joanne Troeger Lavender, Betty Laverty, Janice Troeger Lettieri, Arlene Lowe, Kristen and Merrill Main, Alice Maluso, Catherine Martino, Lillian and Philip Masullo, Daniel Palladino, Ruth Perry, Arlene Platt, Rita Ragno, Andrea Richel, Warren Roche, Nan Rogers, Joan and Al Rotondi, Harris Ruben, Gail Shaffer, Doris Sievering, Marge Solon, Jackie Testa, Trailside Nature and Science Center, U.S. Army–Redstone Arsenal, Lillian van Steenberghe, Mary Lou and Bill Weller, Peg Whiting, and Ruthann Wichelman.

Author's note: Unless otherwise noted, the images in chapter 1 were borrowed from a collection of Columbia School photographs. Those in chapter 6 were borrowed from the personal collection of Joan L. Rotondi. All other photographs are credited at the end of the captions.

INTRODUCTION

Berkeley Heights Revisited continues the photographic journey that began in *Berkeley Heights* (Arcadia Publishing, 1996). Berkeley Heights is typical of suburban towns in many states but is unique in heritage and character. The story of this small, vibrant New Jersey community is told here through images dating primarily from the mid-20th century onward. The book also includes earlier photographs, documents, and maps not available when the first book was compiled. Whatever your age or relationship to our township, may the people and places in these images come alive for you. Perhaps these images will awaken a forgotten memory or will reveal a new piece of history.

—Virginia B. Troeger
January 2005

The following brief index includes subjects covered in both *Berkeley Heights* and *Berkeley Heights Revisited*. The page numbers for *Berkeley Heights Revisited* are listed first.

One

"WHEN WE WERE
A COUPLE OF KIDS"

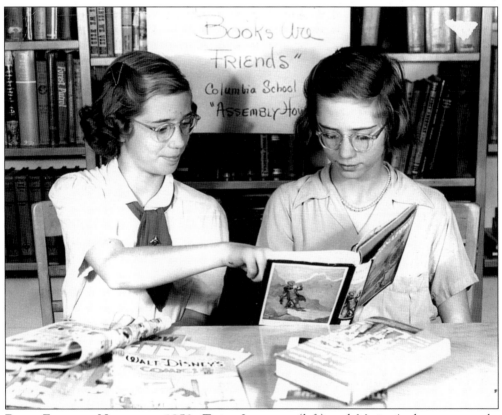

BOOK FRIENDS, NOVEMBER 1950. Twins Jeannette (left) and Maria Anderson, seventh-graders at Columbia School, collect materials in the school library for an upcoming reading project. At that time, Columbia School accommodated all grades through eighth.

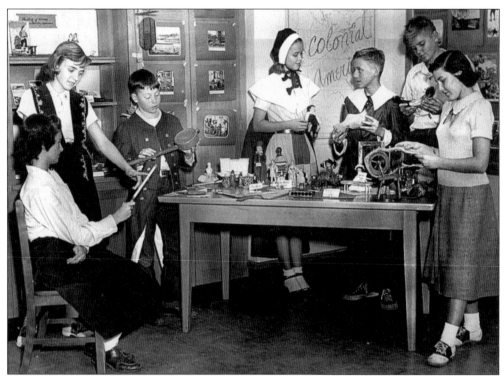

TELLING AMERICA'S STORY, C. 1951. Above, Columbia upper-grade pupils assemble their displays for a Colonial Day exhibit in 1951. From left to right are Joyce Linkletter, Carol Heinz, Bill Elsasser, Jean Horner, Peter Schultz, Richard DeBisco, and Gail Barberich. Below, middle-grade Columbia students bring to life the activities taking place in an old-fashioned store as described in the poem "The General Store," by children's author and poet Rachel Field (1894–1942).

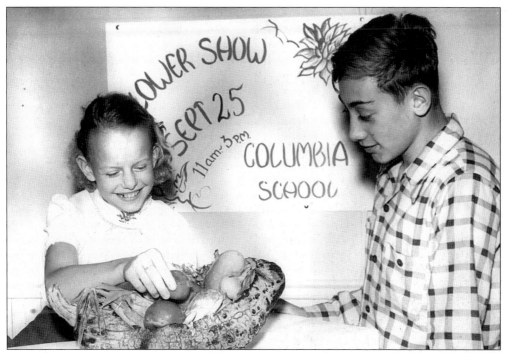

FLOWER SHOW ENTRANTS, C. 1952. Columbia seventh-graders Diane Wadas and Dominick LaSasso decorate a carved squash with vegetables to display in the school flower exhibit. Flower and plant shows were popular projects at this time for students at Columbia School.

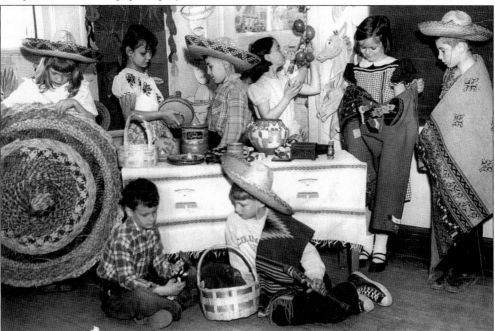

SOUTH OF THE BORDER, C. 1952. Columbia elementary students prepare their exhibit of artifacts and artwork for a Mexican celebration, which was probably the culminating activity for a social studies unit on neighboring countries.

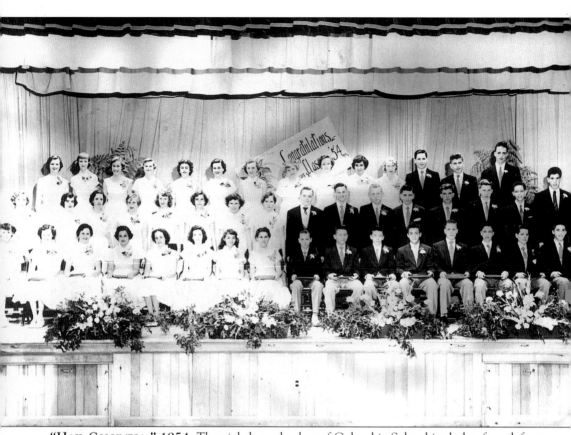

"HAIL COLUMBIA," 1954. The eighth-grade class of Columbia School includes, from left to right, the following: (first row) Shirley England, Mary Margaret Bennett, Carol McKnight, Sara Celega, Patty Allan, Carole Tomlinson, Marie Bassalone, Ann Marie Delia, John Wurst, Gary Benson, Donald Breen, Vincent LaSasso, Bill Manganelli, Richard Martone, Robert Extrom, and Ricky Brown; (second row) Brenda Shultz, Martha Blair, Leanna DelDuca, Diane Van Wettering, unidentified, Barbara Chirba, Joan Gammer, Mary Gartland, William Perry, John Saxton, Raymond Nesbitt, Frank Rendine, Donald Carpenter, George Fuchs, Bill Tuber, and Anthony Delia; (third row) Ruth Meyers, Peggy Hartig, Libby Hinkley, Mary Ellen Patrick, Diane Mondelli, Leona Dally, Frances Allen, Diane Goodrich, Linda Seijas, Marion Calleo, Betsy Gambrill, Bob Benner, Bob DiNunzio, and Herb Belin. (Berkeley Heights Historical Society.)

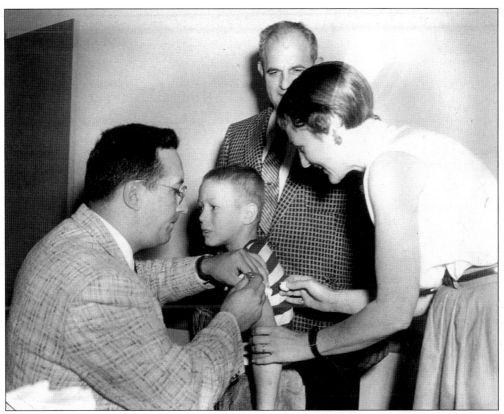

POLIO PREVENTION, C. 1955. School physician Anthony Bebbino inoculates an uneasy student with the newly developed Salk vaccine to prevent poliomyelitis, the deadly paralysis-causing childhood disease. Standing are an unidentified man and school nurse Frances Darcy.

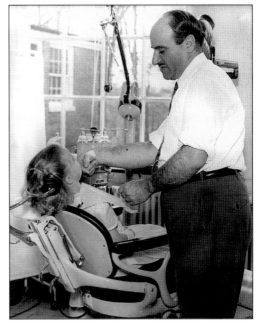

OPEN WIDE, C. 1950. School dentist Anthony Moccia instructs Columbia School first-grader Sandy Horner on the proper care of her teeth. Dental equipment was installed at the school at this time as part of the overall student health program.

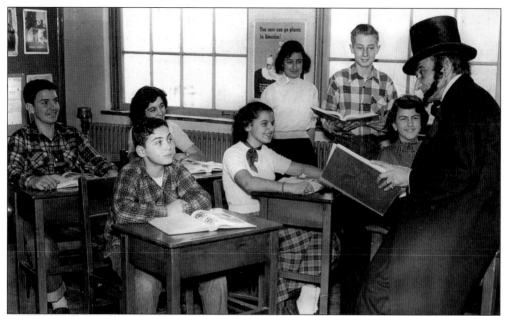

A PRESIDENTIAL VISIT, C. 1955. "Abraham Lincoln" is most likely discussing the problems of slavery and the progress of the Civil War with a class of upper-grade Columbia social studies students. Donald Carpenter (seated at the far left) later became athletic director and an administrator at New Providence High School. He also served as manager of the Berkeley Heights Community Pool for many years.

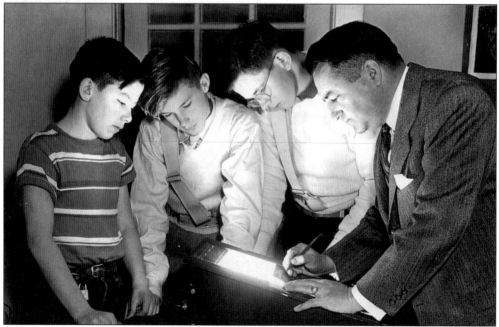

THE COLUMBIA SCHOOL COMMUNIQUE, C. 1955. Supervising principal Kenneth H. Bothwell (right) composes the daily bulletin on the mimeoscope machine. Helping him are, from left to right, Don Greenwood, David Hoeterling, and John Wesner. The students circulated the news sheet to teachers and, on special occasions, to all 490 students at the school.

THE STUDENT OPERATORS CLUB, C. 1957. Columbia School assistant principal Andrew Mariner demonstrates the operation of a 16-millimeter sound projector to club members who are learning to operate the school's audio-visual equipment, which at that time consisted of a stereopticon, an opaque projector, a filmstrip projector, and a tape recorder.

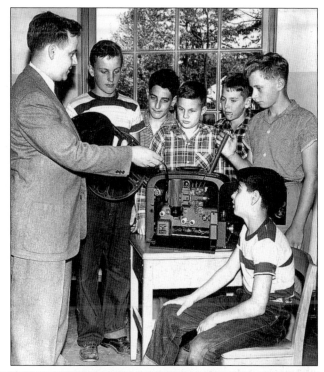

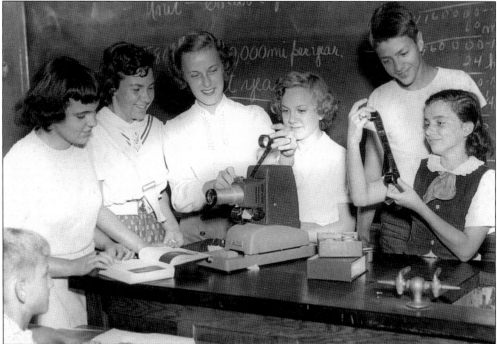

THE AGE OF THE FILMSTRIP, C. 1957. Upper-grade Columbia teacher Margaret K. Kashuba (fourth from left) explains to her students how the filmstrip projector works. Filmstrips were a popular teaching tool in various subjects until videocassettes, compact discs, and other electronic media replaced them. Rose Delia is the third student from the right.

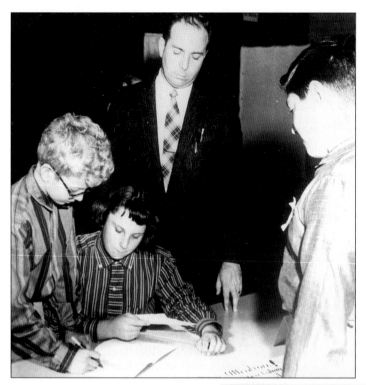

THE FIRST STUDENT COUNCIL ELECTION, NOVEMBER 1957. Helen Keck (seated) and Richard Rosato (right) assist fellow student Douglas Barnett as he registers to vote for officers for Columbia School's newly organized student government. Math teacher and student council advisor Arthur F. Conk (center) oversees the election. Helen Keck, who later became Helen Kirsch, has served for more than 20 years as a member, and more recently as president, of the Berkeley Heights Board of Education.

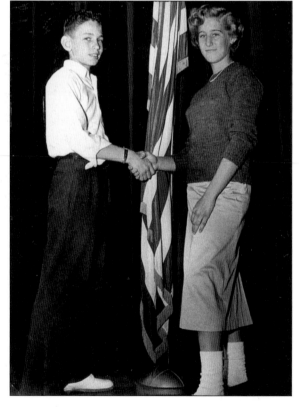

THE NEW PRESIDENT, NOVEMBER 1957. Frank Fish, newly elected president of the Columbia School student government, receives congratulations from his runner-up, Roberta Weissman. Frank and his family lived on Berkshire Drive at the time.

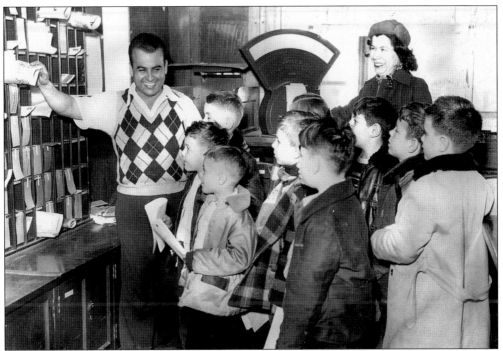

A POST OFFICE VISIT, C. 1955. Primary-grade students are introduced to the inner workings of the local post office by postal worker and letter carrier Jimmy Coletta. Learning about community helpers, such as the police, firefighters, rescue squad members, crossing guards, post office employees, and school bus drivers, has been a traditional part of the primary-school curriculum for many years.

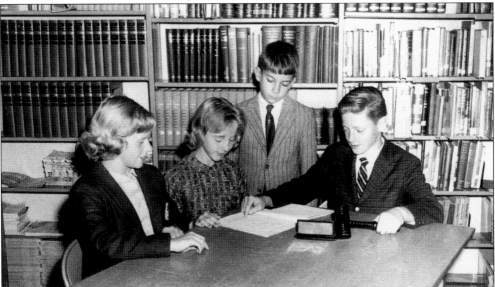

COLUMBIA SCHOOL STUDENT LEADERS, C. 1960. Jim Benedict (right) received 331 votes to his opponent's 205 to be named student council president. Serving with him are, from left to right, Jill Baranoski, recording secretary; Pat Weiler, corresponding secretary; and Simon Mundy, vice president.

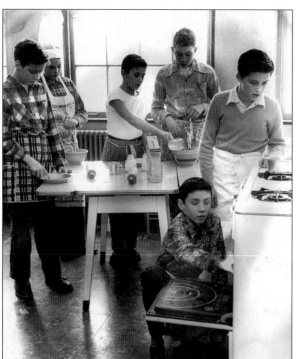

CHEFS IN THE MAKING, C. 1960.
Columbia School boys enjoyed an
extracurricular cooking club until
home economics classes for boys
were added to the curriculum in the
1970s. Industrial arts classes for girls
were also included at that time.

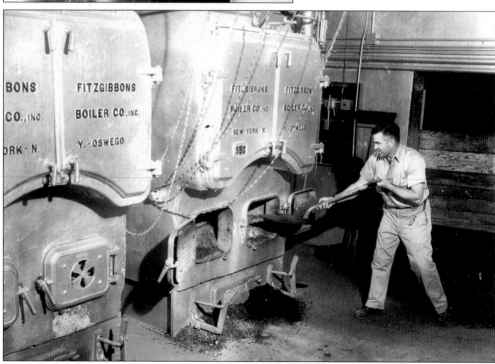

BEHIND THE SCENES, C. 1950. Head custodian Matt Fornaro keeps the school fires burning at
Columbia. A lifelong township resident, Fornaro has served as fire chief, special police officer,
state district fire warden, and warden of the state department of fish and game. He was also a
charter member and the captain of the local rescue squad.

18

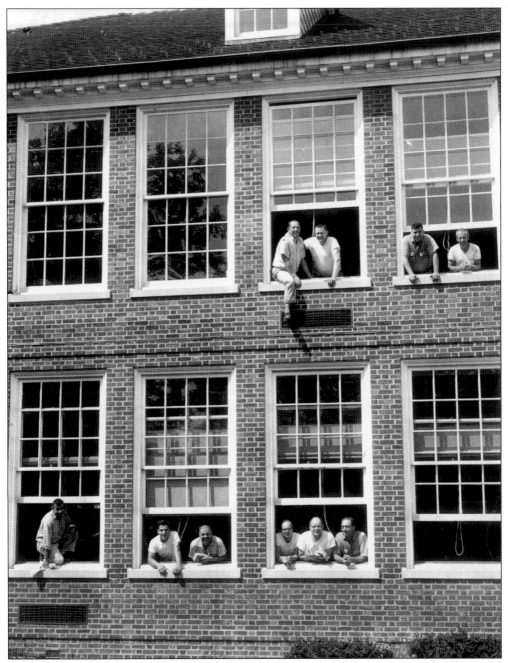

School Custodians on Break, c. 1960s. Enjoying the fresh air at Columbia School are, from left to right, the following: (lower windows) Phil Masullo, Frank Yannotta Jr., Frank Yannotta Sr., Willy Schultz, Louie Levinsky, and Ralph Giacco; (upper windows) Charles Amiano, unidentified, Matt Fornaro, and Mike Fornaro.

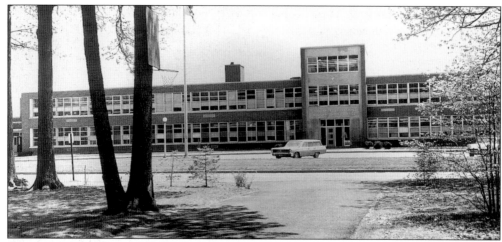

GOVERNOR LIVINGSTON HIGH SCHOOL. Opened in 1960 as Governor Livingston Regional High School at an original cost of $2,669,532, the school was named for William Livingston, a signer of the Declaration of Independence and New Jersey's first state governor under the Constitution of the United States. When the Union County Regional High School district dissolved in 1997, the high school (located in the Murray Hill section of the township) joined the Berkeley Heights school district, and the word *Regional* was dropped from the name.

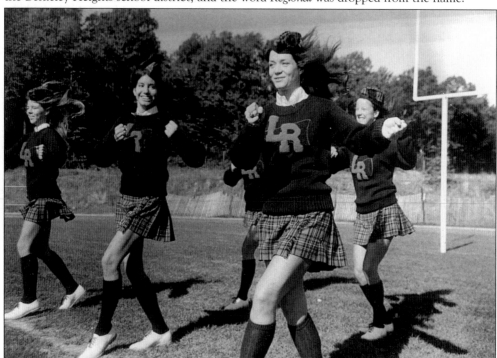

"SPIRIT, SPIRIT, THAT'S THE NAME," C. 1970. Governor Livingston cheerleaders have traditionally added pep and enthusiasm at football, soccer, and basketball games and often at state meets. English teacher Gail Shaffer, assisted by other faculty members, coached the cheerleading squad for 35 years. Recipient of the New Jersey State Teacher of the Year Award for the 1992–1993 school year, Shaffer retired from Governor Livingston in 2001 after 40 years of teaching. (Gail Shaffer.)

THE GOVERNOR LIVINGSTON HIGHLANDER
BAND, C. 1970. Band members gather in
the stands during a home football game.
Under the direction of Daniel Kopcha, and
earlier under Forrest Bartlett, the award-
winning band has always maintained a
strong reputation for excellence in both
marching maneuvers and musical
performance while blending contemporary
sounds with old-world traditions. The
Highlanders wear the authentic Royal
Stewart tartan and the uniform of the Black
Watch Regiment. (Gail Shaffer.)

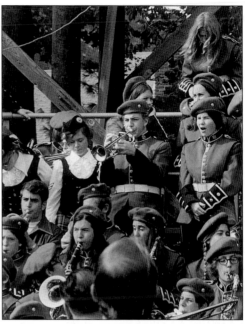

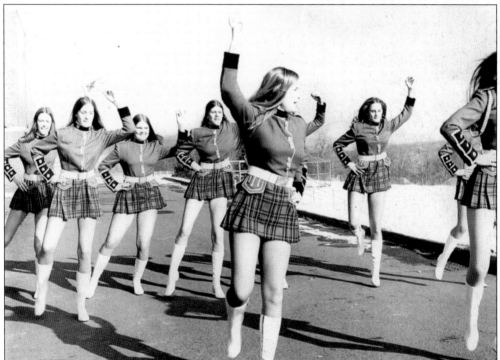

THE GOVERNOR LIVINGSTON BAND FRONT, C. 1970. In 1981, the *Claymore* (the Governor
Livingston yearbook) stated: "Being part of the Highlander Band is much more than just going
to football games and on band trips. Being part of the band means many long hours of practicing
as the band does every day during 5th period as well as after school and on weekends. . . .
Admittedly, it is a lot of work but such great pride is derived from being part of such a fine group
as the Highlander Band more than makes up for it!" (Gail Shaffer.)

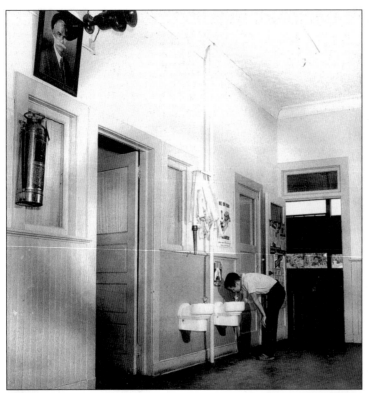

COLUMBIA SCHOOL, ORIGINAL BUILDING, c. 1960. Under the watchful eyes of longtime teacher and supervising principal William Woodruff (in the portrait above the fire extinguisher), a student stops at the water fountain in the hall for a quick break from class. This building was later remodeled to house the administrative, board of education, and special services offices of the Berkeley Heights township schools.

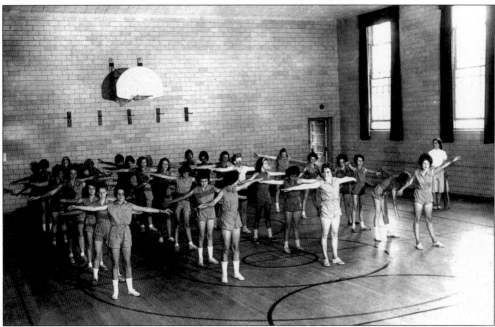

PHYSICAL EDUCATION, c. 1963. One-piece gym suits in light blue or green were the official attire for girls at Columbia School in the 1960s. This photograph (taken in the original gymnasium, which accommodated only 30 students at a time) was one of many pictures used in promotional exhibits to emphasize the need for an addition to the school.

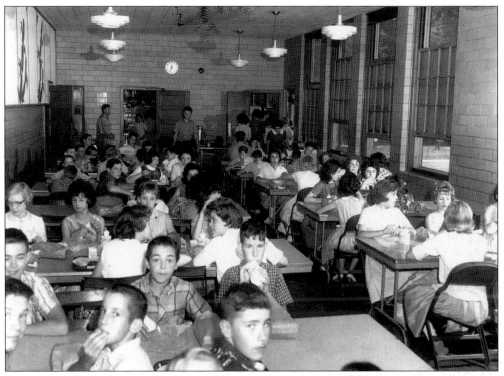

MORE SPACE NEEDED, C. 1963. The photographs used in the exhibits calling for an addition to Columbia School included these images of the crowded student cafeteria (above) and the undersized school kitchen (below).

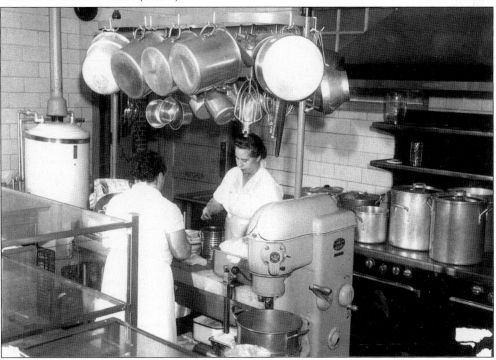

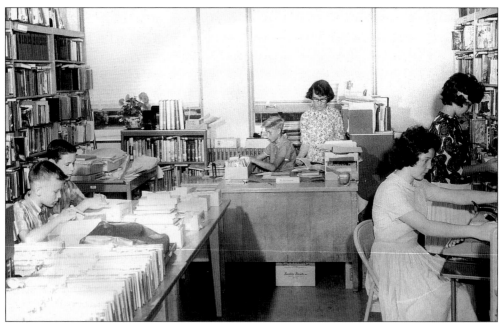

THE COLUMBIA LIBRARY, C. 1963. Librarian Amy Hausamann and her student committee work hard to keep books shelved and files in order in their small space. When a new, larger library was opened at Columbia a few years later, it was named in memory of board of education and Parent-Teacher Association member Susan Hoag Deland, a mother of three, who died in 1963 at age 35.

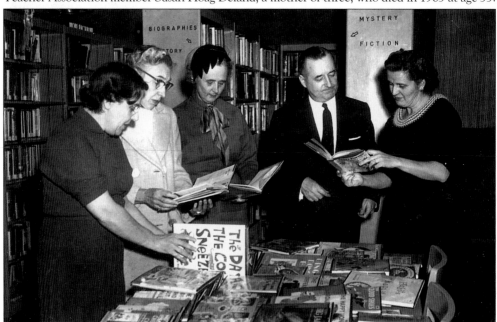

SCHOOL AND PUBLIC LIBRARY COOPERATION, 1963. From the time the Berkeley Heights Public Library opened in 1953, local teachers often met with library director Frances Wrathall (far left) to examine and discuss new children's books. Seen visiting the public library are teachers L. A. Purdy (second from left), Marguerite Woods, and Gertrude Jedry (far right), with superintendent of schools Kenneth H. Bothwell.

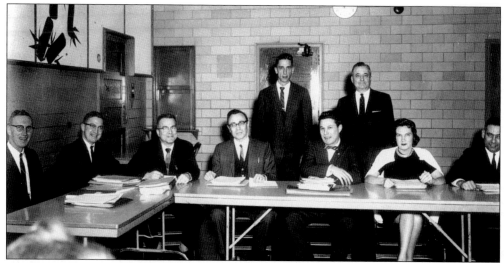

BOARD OF EDUCATION MEMBERS, C. 1963. The members of the board are assembled for their monthly Monday evening meeting at Columbia School. From left to right are Roy Estoppey, Bob Isleib, Bob Chamberlain, Albert Goldberg, John Walklet (secretary to the board), Clifford Rowland, Kenneth H. Bothwell (superintendent of schools), Sally Barry, and Benson Tuschler.

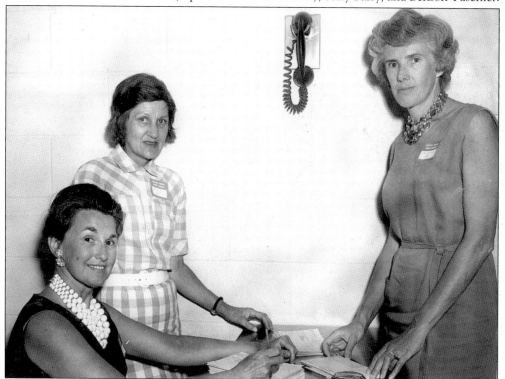

DISTRICT MEDICAL DEPARTMENT, C. 1965. School nurses Dorothy Powers (seated), Frances Darcy (standing left), and Svea Eppler review their plans for the health of Berkeley Heights students. Eppler was also an active member and officer of the Berkeley Heights Rescue Squad for many years. (Another Dorothy Powers served as librarian at Mountain Park School, retiring in 1979.)

25

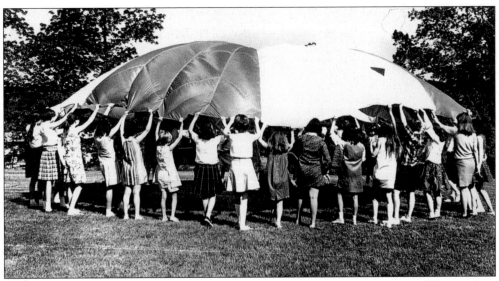

UP, UP, AND AWAY, C. 1967. Under the direction of their teacher, Margaret Whiting (not pictured), a physical education class at Hughes School exercises with an authentic parachute. Whiting introduced the parachute as a teaching tool to the district to encourage teamwork and to build upper-body strength. Girls and boys in grades four through six were separated for gym classes at that time. (Peg Whiting.)

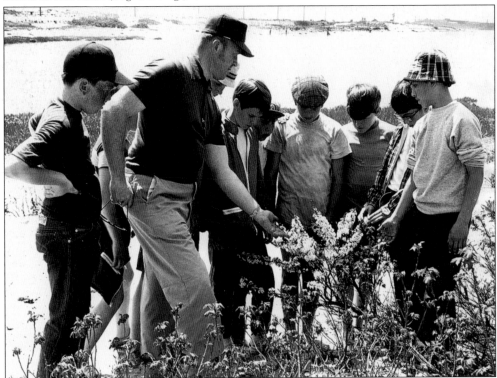

ON LOCATION AT SANDY HOOK, C. 1970. Sixth-grade teacher Joseph Evan and a group of students from Hughes School examine the flora and fauna along the shore on a science field trip. Thomas Murray and Burt Arnold also taught sixth grade at the school at this time.

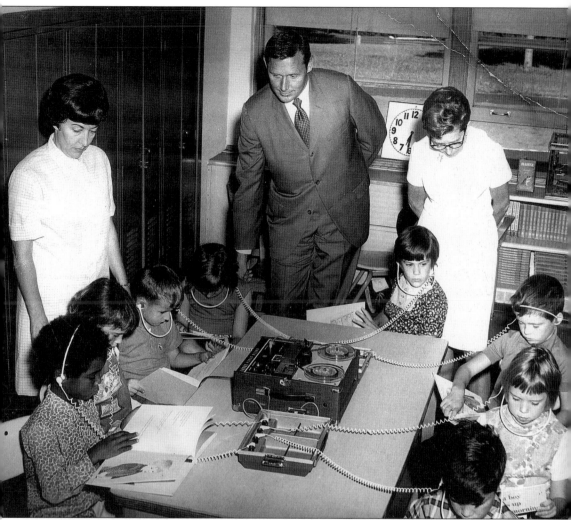

LISTEN UP, DECEMBER 1968. Hughes School second-graders improve their listening and reading skills at the new listening station in their classroom. Standing are, from left to right, second-grade teacher Alice Maluso, superintendent of schools Ehrling W. Clausen, and reading specialist Nan E. Rogers. Maluso's second-graders are, clockwise from left, Sydney Senhouse, Cynthia Troeger, Robert Garrison, Susan Grominger, Kathy Koehler, Derek Rae, Kathy Anderson, and Donald Cram. Hughes School, on Snyder Avenue, was known as Berkeley School at this time and was later renamed the Thomas P. Hughes School in honor of its first principal, who earlier had served as principal and history teacher at Columbia School. Hughes was also responsible for taking many of the photographs in this chapter and is remembered for his rousing Flag Day programs held every year at Hughes School.

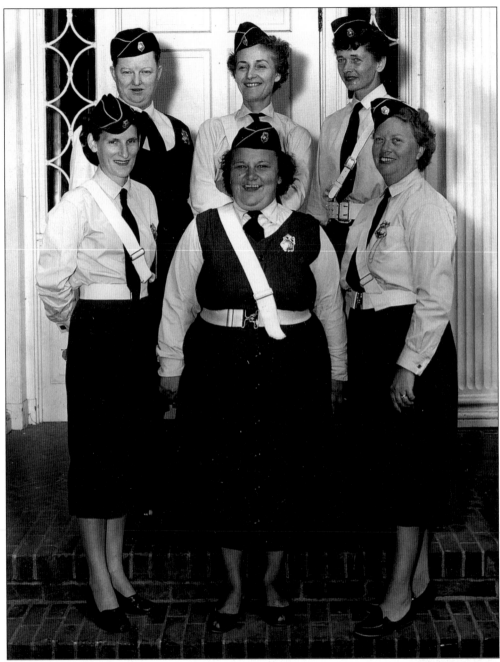

SAFETY FIRST, C. 1965. The township's crossing guards have always performed a vital service for the schoolchildren of Berkeley Heights. Assembled on the steps of town hall are, from left to right, the following: (first row) Lillian Masullo, Margaret Bundy, and Ida Phillippi; (second row) an unidentified crossing guard, Dorothy Siksnius, and Doreen Fenske. (Berkeley Heights Historical Society.)

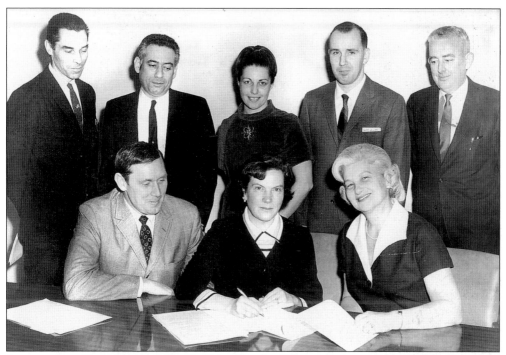

SIGNING THE CONTRACT, 1969. Berkeley Heights Education Association (BHEA) members meet with the board of education to sign a new salary and medical insurance contract for the teaching staff. From left to right are the following: (seated) superintendent of schools Dr. Ehrling W. Clausen; board president Sally Barry; and BHEA president Evalyn Geftic, a sixth-grade teacher at Mountain Park School; (standing) Columbia School teacher George Somers; board member Benson Tuschler; unidentified; Woodruff School teacher Robert Judd; and Hughes School teacher Thomas Murray.

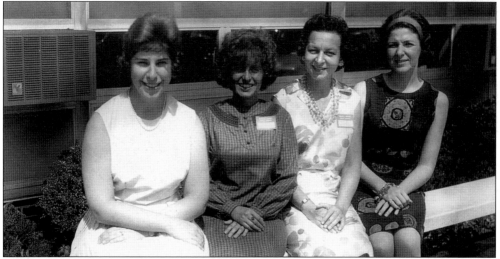

BHEA OFFICERS, C. 1970. Heading the Berkeley Heights Education Association are, from left to right, corresponding secretary Nancy Thompson, recording secretary Willa Brown, president Ann Marie Kralovich, and vice president Judith Collins. Treasurer Virginia Hensler is not pictured. Kralovich served as the psychologist for the township's schools at this time.

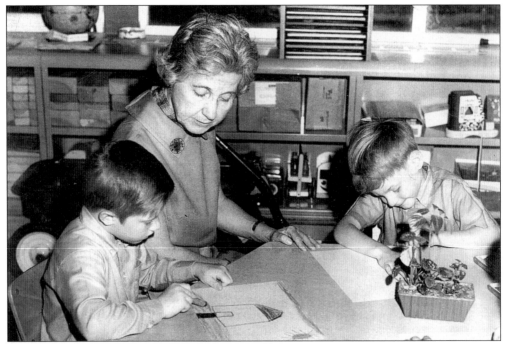

PRIMARY-GRADE TEACHERS, C. 1969. Frances A. Linskill (above), who retired in 1970 from Woodruff School, observes her kindergartners at work on an art project. Judy Bryceland (below), who taught at Hughes School, works with her first-grade class on reading skills. Student Carol Nast is seated at lower right.

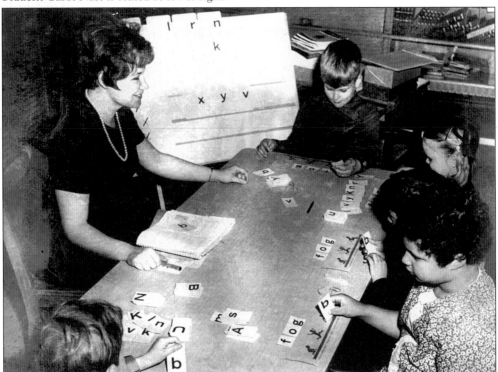

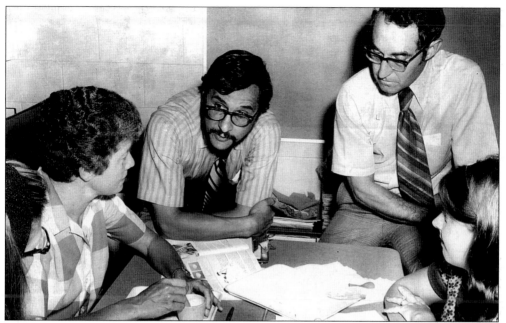

THE NEW SCIENCE CURRICULUM, SEPTEMBER 1971. Woodruff School primary-grade teachers review the Science Curriculum Improvement Study (SCIS) with Woodruff School principal Joseph Ierardi (center) and assistant superintendent of schools Clifford Greenwald. The teachers are, from left to right, Cathy Doremus, Ann Coffin, and Diane Bergvall. The program provided a functional understanding of basic science concepts, with emphasis on laboratory work.

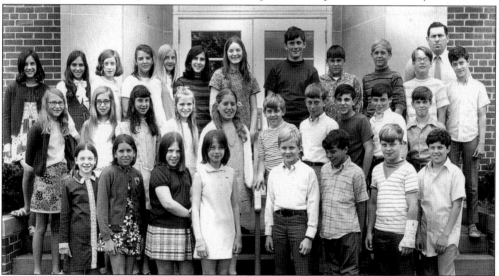

BURT ARNOLD'S HOMEROOM, C. 1970. Burt Arnold's class was one of three 30-pupil sixth-grade classes at Hughes School. By 1980, the school population in Berkeley Heights dropped drastically as the children of the baby boomers moved into the higher grades. Hamilton Terrace, the newest school to be built in town, was closed and became the Westlake School for out-of-district students with special needs. In the mid-1990s, Columbia changed to a middle school for grades six through eight. In 1997, Hamilton Terrace reopened as the Early Childhood Center, which accommodates the district's kindergarten and first-grade pupils.

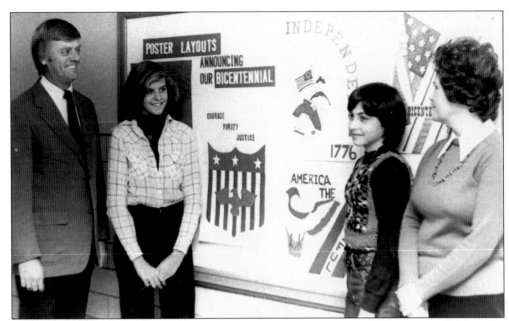

CATCHING THE BICENTENNIAL SPIRIT, 1975. Eighth-grade art students at Columbia School view their patriotic display in preparation for the 1976 national bicentennial celebration. Standing are, from left to right, Columbia principal John Muly, art students Stacie Granger and Lisa DeBanico, and Columbia art teacher Marilyn Kelley. Muly later served as principal of Woodruff School.

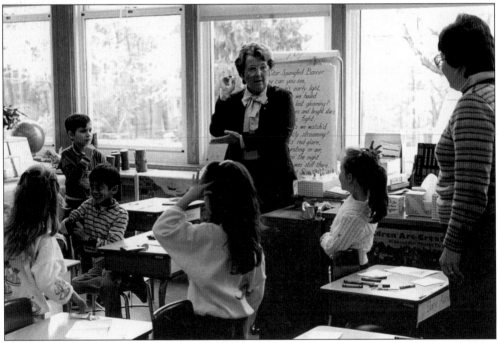

A FOREIGN LANGUAGE FOR LUNCH, C. 1975. Columbia foreign language teacher Charlene Rode Harvey (far right) presents an elementary French lesson during lunchtime to the second-grade class of Doris Richards (center) at Hughes School.

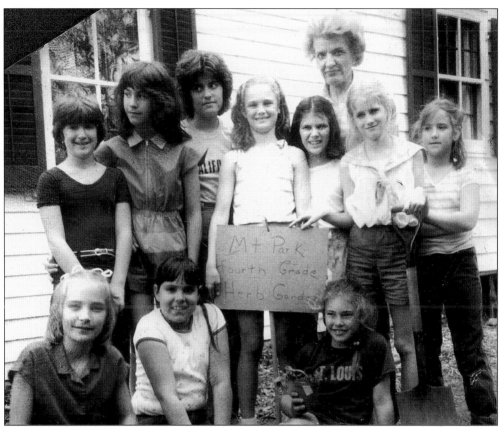

STUDENT GARDENERS, MAY 1983. Mountain Park teacher Julia Donnelly and the girls in her fourth-grade class gather for a photograph during the planting of a Colonial herb garden at the Littell-Lord Farmstead on Horseshoe Road. From left to right are the following: (first row) Aili Milles, Melinda Graham, and Gabrielle Vinhal; (second row) Stephanie Loria, Lauren David, Nicole Raver, Jenny Dalton, Rachel Rust, Carol Thornber, and Allyson McDermid. (Berkeley Heights Historical Society.)

DRIVER ED, C. 1980. Traffic-safety sergeant Mickey Monica (left) and township municipal judge Donald P. Bogosian discuss New Jersey's traffic laws with Governor Livingston High School students who are preparing to take the tests for their driver's licenses.

No Foolin', 1992. Hughes School teachers pause on April 1, 1992, for a photo opportunity with superintendent of schools Dr. Robert T. Stowell. The teachers are, from left to right, Irene Cash, Jody Pfeiffer, Kim Hackenberg Sokol, and Barbara Sheffer.

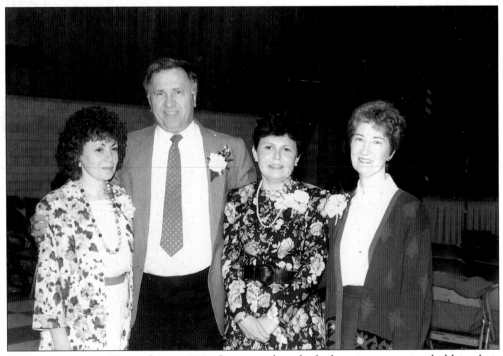

Teachers of the Year, June 1992. Seen at a board of education reception held in their honor at Columbia School are, from left to right, Elaine Insinnia (Columbia School), Ray Sugalski (Woodruff School), Lorraine Knight (Mountain Park School), and Joan Orlando (Thomas P. Hughes School).

Two
ALONG MOUNTAIN AVENUE

ONCE A TRUE COUNTRY ROAD, 1913. This section of Mountain Avenue at Plainfield Avenue (pictured in a view facing west, toward the township of Warren) included about seven homesteads. Park Avenue was the only side road, and was known then as Union Avenue. According to Fred S. Best, historian of Berkeley Heights for many years, this area of Mountain Avenue followed a dividing line between large acreages as originally planned in the 1730s by the Elizabethtown surveyors. (Berkeley Heights Historical Society.)

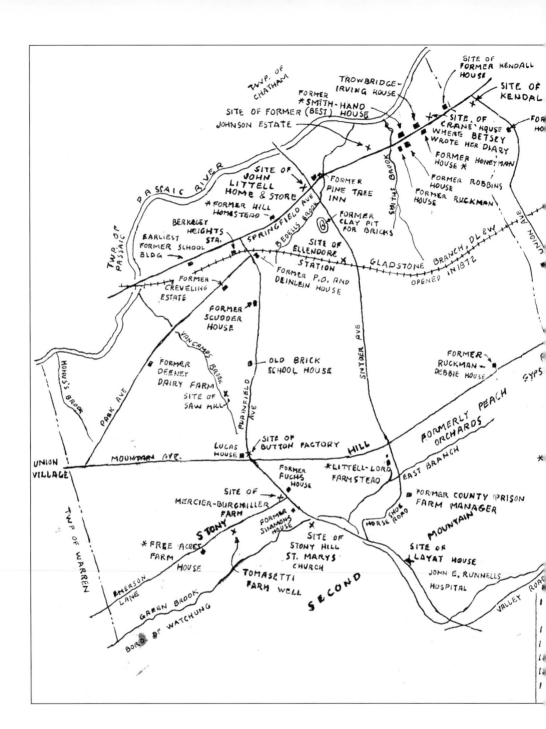

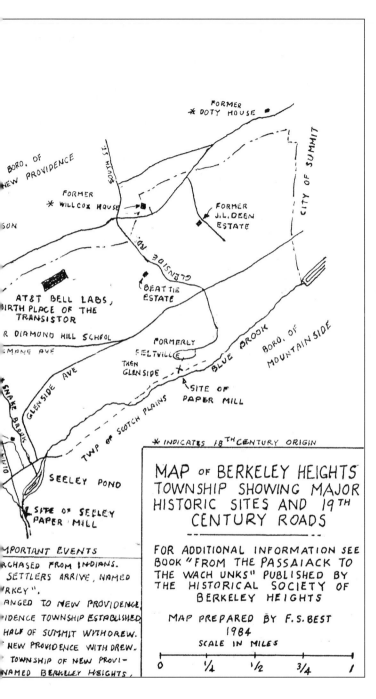

FORMER
* DOTY HOUSE *

BORO. OF
NEW PROVIDENCE

SOUTH ST.

CITY OF SUMMIT

FORMER
* WILLCOX HOUSE

FORMER
J.L. OEEN
ESTATE

GLENSIDE RD.

BEATTIE
ESTATE

AT&T BELL LABS,
BIRTH PLACE OF THE
TRANSISTOR

R DIAMOND HILL SCHOOL

MANE AVE

FORMERLY
FELTVILLE
THEN
GLENSIDE

BLUE BROOK

BORO. OF
MOUNTAINSIDE

SITE OF
PAPER MILL

GLENSIDE AVE

SNAKE BROOK

TWP. OF SCOTCH PLAINS

* INDICATES 18TH CENTURY ORIGIN

SEELEY POND

SITE OF SEELEY
PAPER MILL

MPORTANT EVENTS

RCHASED FROM INDIANS.
SETTLERS ARRIVE, NAMED
RKEY".
ANGED TO NEW PROVIDENCE.
IDENCE TOWNSHIP ESTABLISHED
HALF OF SUMMIT WITHDREW.
NEW PROVIDENCE WITH DREW.
TOWNSHIP OF NEW PROVI-
NAMED BERKELEY HEIGHTS,

MAP OF BERKELEY HEIGHTS
TOWNSHIP SHOWING MAJOR
HISTORIC SITES AND 19TH
CENTURY ROADS

FOR ADDITIONAL INFORMATION SEE
BOOK "FROM THE PASSAIACK TO
THE WACH UNKS" PUBLISHED BY
THE HISTORICAL SOCIETY OF
BERKELEY HEIGHTS

MAP PREPARED BY F.S. BEST
1984
SCALE IN MILES

0 ¼ ½ ¾ 1

A LOCAL MAP, 1984.
Historian Fred Best has included the location of many historic township sites on this map. Mountain Avenue is shown as one of the early main roads through Berkeley Heights, but Springfield Avenue, which parallels the Passaic River, was the major east–west artery through town. Although heavily traveled, treelined Mountain Avenue continues to retain its rural character. (Berkeley Heights Historical Society.)

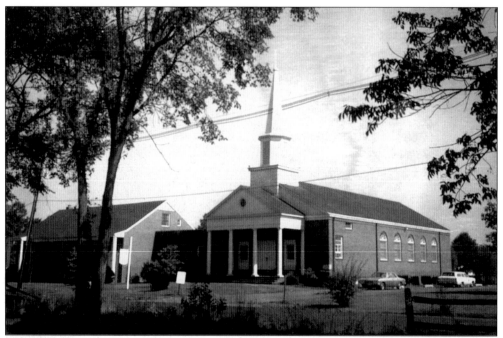

THE CHURCH AT THE CROSSROADS, C. 1980. Although located just over the border of Berkeley Heights in Warren, the Union Village Methodist Church maintains a Berkeley Heights mailing address, and many of its members are township residents. The original church was built in 1825, and this sanctuary was constructed in 1961. (Mary Lou Weller.)

A STREET SCENE, MARCH 1959. Mountain Avenue (Union County Road No. 622) is shown in a view facing east, toward Plainfield Avenue. A white line divides the road at this time, but the traffic light at Snyder Avenue and Horseshoe Road and the walkways have not yet been installed. This photograph is one of many taken by township photographers during the installation of the sewers that replaced septic tanks in various parts of town.

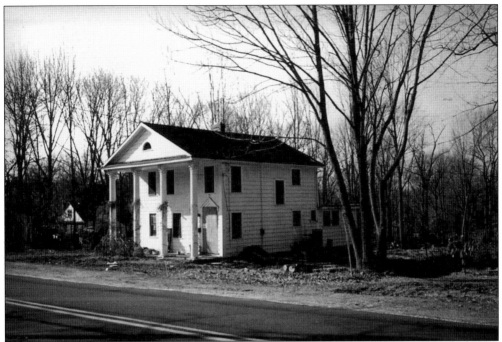

EARLY HOMES ON MOUNTAIN AVENUE. These two homesteads, located between Plainfield and Cornell Avenues on the north side of Mountain Avenue, were razed for new construction of larger houses in the 1990s. These residences are examples of the varying styles of smaller, individual homes that were built along the older streets of town before and shortly after World War II. Pictured above is the home that used to stand at 819 Mountain Avenue. (Joan L. Rotondi.)

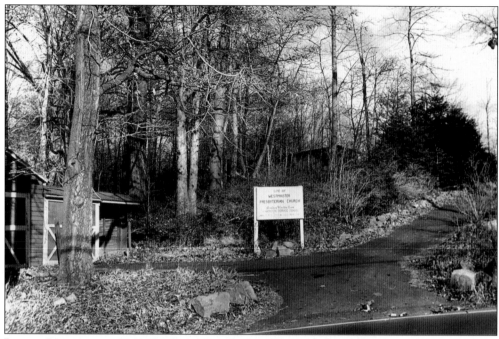

LUCAS CORNERS, C. 1961. In the spring of 1961, the Presbytery of Morris and Orange of the Presbyterian Church recognized the need for a church in the growing Berkeley Heights area. With the help of Central Presbyterian Church in Summit, a five-acre tract of land owned by Sarah B. Lucas on the northeastern side of the intersection of Mountain and Plainfield Avenues was selected by a local planning committee as the site for the new house of worship. (Westminster Presbyterian Church.)

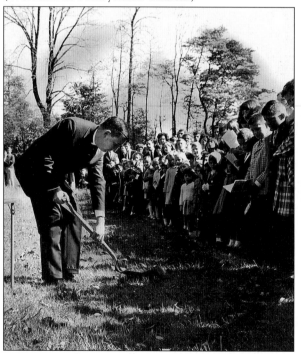

CHURCH GROUNDBREAKING, OCTOBER 24, 1965. After several years of planning, the congregation (under the name Westminster Presbyterian Church) marched to the site of their proposed building, singing "The Church is One Foundation." Their minister, Rev. Robert B. Sheldon, turned over the first shovelful of soil. As part of the sale arrangements, Sarah B. Lucas permitted the congregation to use the house on the property (576 Plainfield Avenue) for an office and other church activities until the building was completed. (Westminster Presbyterian Church.)

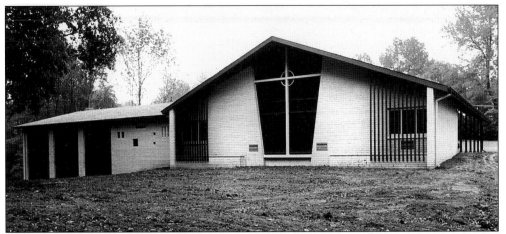

A Building at Last, November 1966. Two dedication services for the new Westminster Presbyterian Church building were held on November 20, 1966, with Rev. Robert B. Sheldon officiating and organist Janet Stevens directing the adult and youth choirs. Members of the dedication committee included Elaine Hessey, Sarah B. Lucas, Nancy Farrar, and Mrs. Robert McCullum. Reverend Sheldon's wife, Grace, taught kindergarten at Mountain Park School for many years. (Westminster Presbyterian Church.)

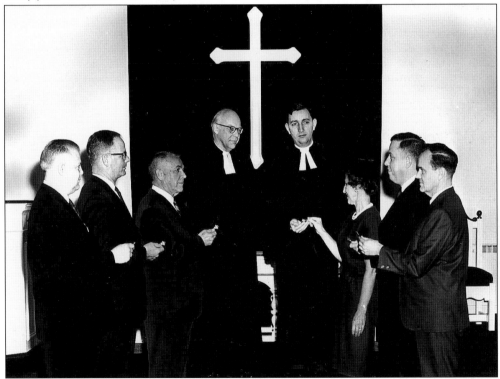

The Presentation of Keys, November 1966. During the dedication services, the building committee of Westminster Presbyterian Church presented the church keys to the clergy. From left to right are Fred Blendinger, Donald F. Irving Jr., Roland P. Beattie, Rev. Frank A. Pehrson (executive of the Presbyterian Synod of New Jersey), Rev. Robert B. Sheldon, Jane Murray, Albert E. Ott, and Richard Dent (chairperson). (Westminster Presbyterian Church.)

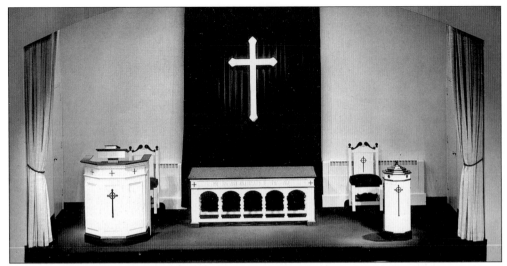

A HAND-BUILT CHANCEL, NOVEMBER 1966. Church charter member Walter Gebauer designed and built these pieces of chancel furniture for Westminster Presbyterian Church. Most of the walnut and poplar wood used to make the furniture was taken from trees cut in nearby Meyersville. Gebauer constructed the altar furnishings in the woodworking shop at his home. The name of the church refers to the Westminster Confession of Faith, one of the early standards of belief of the Presbyterian Church, adopted in the United States in 1729. (Westminster Presbyterian Church.)

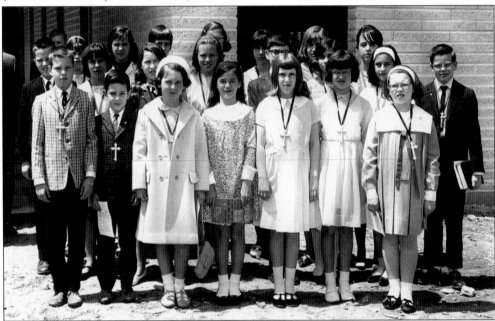

THE WESTMINSTER YOUTH CHOIR, NOVEMBER 1966. These girls and boys sang at one of the two church dedication services. From left to right are the following: (first row) Kevin Opalek, Terry Opalek, Leslie Sutherland, Colleen Lundy, Beth Sheldon, Helen Irving, and Nancy Tyler; (second row) Mark Gorham, Betsy Walklet, Daryl MacFarlane, Sharon Oakes, Bob Shreibus, Joan Savoy, Vicki Eisele, and Jon Oakes; (third row) Barbara Haldeman, Laura Burton, Peggy Sefton, Debbie Oakes, Linda Walklet, Kim Jones, and Cindy Opalek. (Westminster Presbyterian Church.)

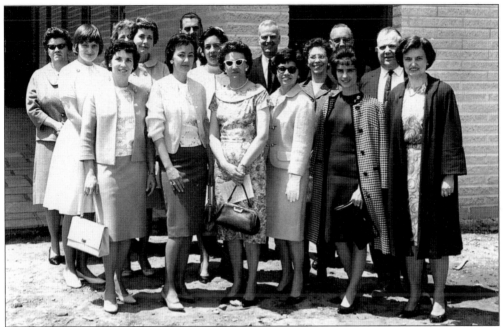

THE WESTMINSTER ADULT CHOIR, NOVEMBER 1966. These participants in the dedication services are, from left to right, as follows: (first row) Nancy Walklet, Irene Opalek, Doris Opdyke, Carol Friedwalk, Betsy Ewertsen, and choir director Janet Stevens; (second row) Cindy Irving, Elaine Hessey, Barbara Eisele, Barbara Preston Little, and Fred Blendinger; (third row) Dot Blendinger, Ruth Gray, C. Dudley Parker, Warren Stanglein, and John Van Nest. (Westminster Presbyterian Church.)

THE WESTMINSTER PRESBYTERIAN CHURCH, CHRISTMAS 1974. By this time, the church had become a familiar site at Mountain and Plainfield Avenues. In 2002, the congregation celebrated its 40th anniversary and remains an enduring presence in town. An older church sign was replaced at this time with a lighted sign and message board contributed by the Sonnenberg family in memory of husband and father Ed Sonnenberg. (Westminster Presbyterian Church.)

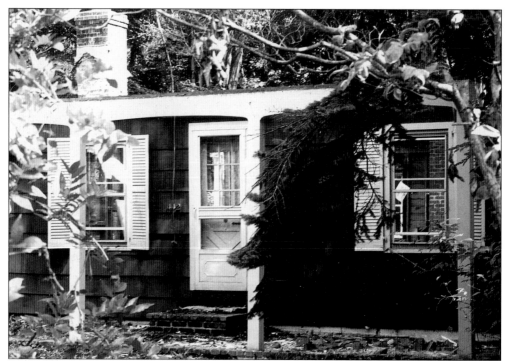

A Transformation, 2004. Above, an older house on Mountain Avenue, near the intersection of Horseshoe Road and Snyder Avenue, is pictured before the start of an extensive remodeling project. Hidden behind tall bushes and trees, the house stood empty and almost unnoticed before the renovation started. Below, with the remodeling project nearly completed, the house has been greatly enlarged with the addition of a second story. (Virginia B. Troeger.)

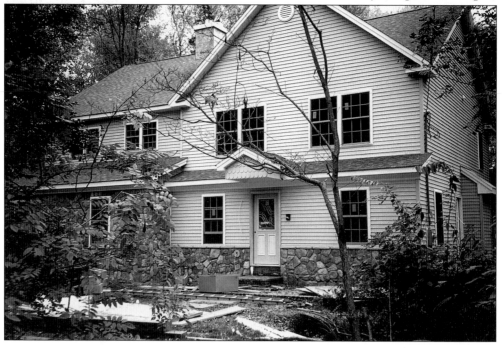

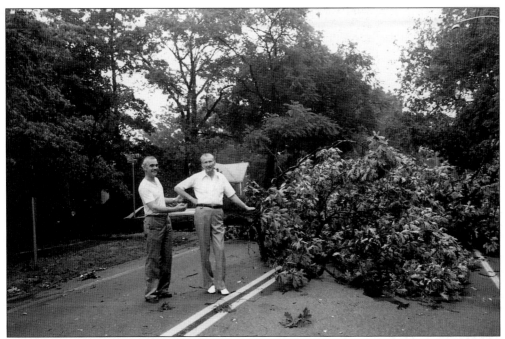

Storm Damage, June 1984. Mountain Avenue resident Jim Warren (right) and a neighbor inspect a large tree that has blown down across the avenue at the intersection of Cedar Green Lane. In 1982, Warren was named the state bowling champion for the 65–69 age group in the New Jersey State Senior Citizens' Bowling Tournament. (Joan L. Rotondi.)

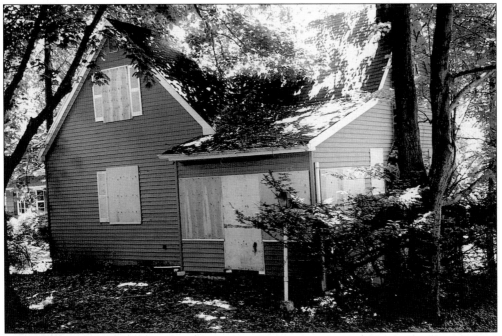

Last Days, June 2004. For years the home of the Hamm family, the modest blue house at 364 Mountain Avenue stands forlorn and boarded-up, awaiting the wrecker's ball. A road leading to new houses is proposed for the site. (Virginia B. Troeger).

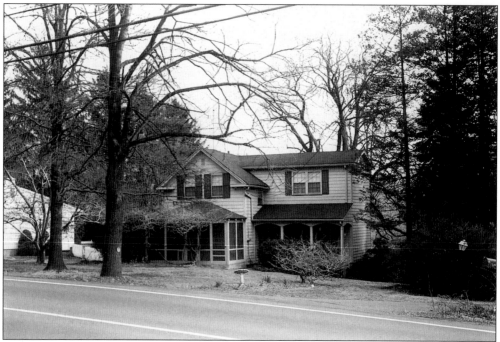

152 Mountain Avenue, c. 1980. This once-familiar homestead across from Spice Hill Road disappeared in the 1990s to make room for a large Colonial house on the property. Other older dwellings in the vicinity were also razed at the time for new home developments. (Berkeley Heights Historical Society.)

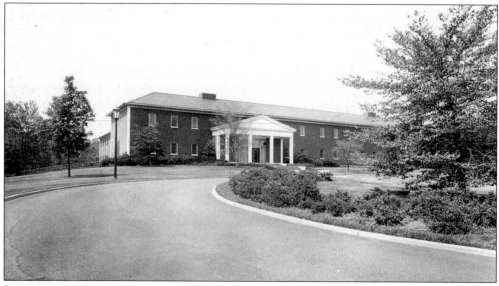

Dun and Bradstreet, c. 1980. Originally the offices of the engineering firm C. F. Braun and Company, this complex at the corner of Mountain Avenue and Diamond Hill Road housed the world headquarters of Dun and Bradstreet until the company moved out of town. Now known as the D&B Corporation, the firm is the leading provider of global business information and manages a vast commercial database with information on 83 million companies. (Township of Berkeley Heights.)

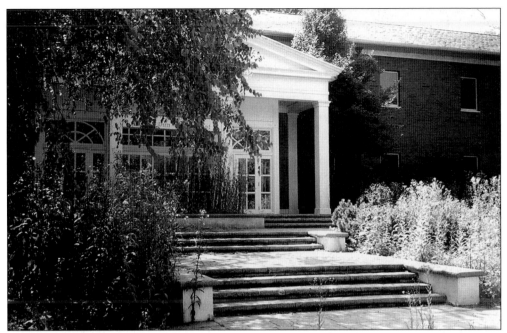

THE FORMER D&B BUILDING, AUGUST 2004. The Mountain Development Corporation of Clifton purchased the former D&B complex of four buildings in 2004, and shortly thereafter, the Summit Medical Group signed a long-term lease for the property. Tall weeds have grown quickly around the buildings as they await demolition to accommodate a new, three-story medical office building. (Virginia B. Troeger.)

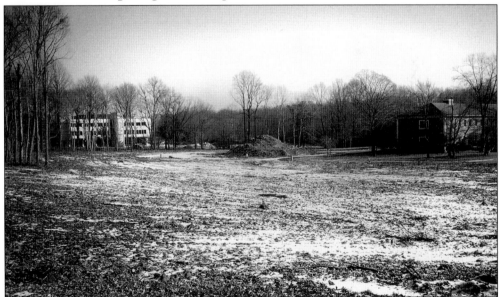

A CHANGING LANDSCAPE, DECEMBER 2004. Although new plantings are promised when the Summit Medical Group complex is completed, area residents and passing motorists experienced a great sense of loss at the sudden disappearance of many of the tall trees and shrubs that had long been a welcome sight at this corner of Mountain Avenue and Diamond Hill Road. (Virginia B. Troeger.)

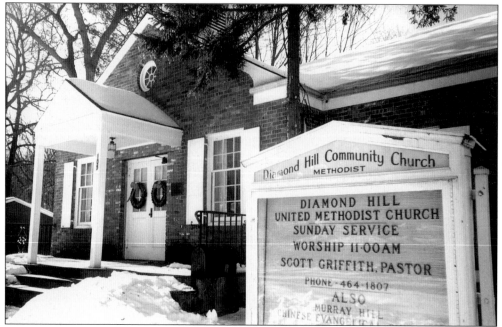

THE DIAMOND HILL CHURCH, DECEMBER 1995. The Diamond Hill United Methodist Church stands next door to the former Dun and Bradstreet building on Diamond Hill Road, not far from the intersection with Mountain Avenue. The church had its beginnings during World War II; when parents in the Blue Mountain section of town found it difficult to drive their children to neighboring communities for Sunday school because of gasoline shortages, they organized a Sunday school in the nearby home of Mr. and Mrs. Clinton Fogwell. (Joan L. Rotondi.)

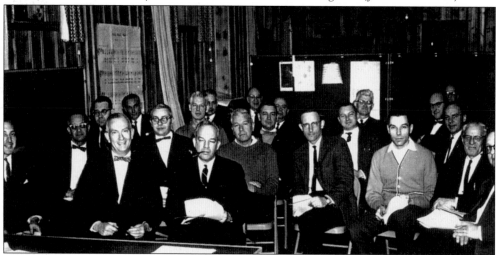

THE MEN'S CLUB, C. 1960. This Diamond Hill Church organization was active for many years. Members in this photograph include George Somers, Charlie Day, Carl Klein, Rudy DeRoode, Bruce Van Order, Fred Becker, Bill Brown, Fred Messner, Rev. Morrell C. Ruby, and Don Drumm. In the late 1940s, a group of area residents decided that the Methodists would organize a church in the Berkeley Heights–Blue Mountain section, and the Presbyterians would organize in the Mountainside–Sky Top area. Both would serve as community-type churches, rather than strictly denominational houses of worship. (The Diamond Hill United Methodist Church.)

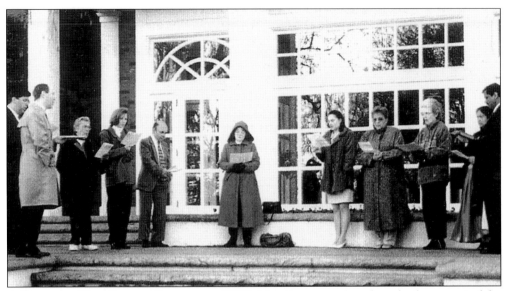

A DIAMOND HILL SUNRISE SERVICE, C. 1995. Members are gathered on the front steps of the former Dun and Bradstreet building for an Easter dawn service, an old tradition at the church. The Diamond Hill United Methodist Church first opened for worship in 1948. A new sanctuary was built in 1964–1965, and in celebration of its first 20 years, the congregation held an ecumenical service on Thanksgiving Eve 1968, with ministers and priests of all neighboring churches participating. (The Diamond Hill United Methodist Church.)

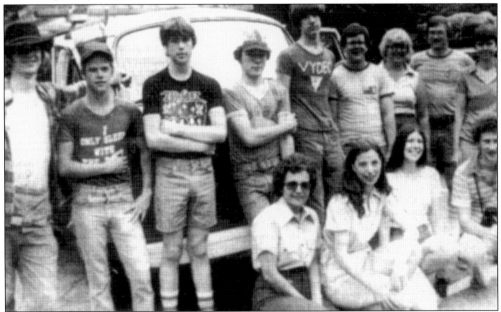

A DIAMOND HILL MISSION TRIP, C. 1980. Among the participants ready to depart for Appalachia are Don Farnsworth, Hal Brenner, Doug Cox, Andy Nordgren, Carolyn Farnsworth, Rev. James K. Price, Shirley Klaitch, Joan van Baalen, and Judy Nordgren. On the home front, the congregation undertook a fund-raising project in the late 1990s to make the church handicapped accessible. A wheelchair lift, large-print materials, and new lighting were added. (The Diamond Hill United Methodist Church.)

KERSBERGEN NURSERIES

Landscape Contractors and Nurserymen

Springfield Avenue Summit 6-3136 New Providence, N. J.

HILLTOP SERVICE STATION

Bob Thompson

Berkeley Heights, N. J. Fanwood 2-9840

GEO. H. RILEY APPRAISALS

& MORTGAGES

HELEN G. RILEY REAL ESTATE

G. & G. GROCERIES

Millington 7-0654 7-0363 Gillette, N. J.

Summit 6-6292 John Amodeo, Prop.

BERKELEY GARAGE

Springfield and Plainfield Aves. Berkeley Heights N. J.

BERKELEY BAKERY

Berkeley Heights, N. J.

MAY'S LUNCHEONETTE

Summit 6-1781 Berkeley Heights, N. J.

BERKELEY BARBER SHOP

Springfield and Plainfield Aves. Berkeley Heights, N. J.

SUmmit 6-5426 J. J. Monica, Prop.

MOUNTAIN CLEANERS & DYERS

Pick up and delivery service Store Hours:9 A. M. to 6 P. M.

500 Plainfield Avenue Berkeley Heights, N. J.

Summit 6-6055 J. W. Kratz, Prop.

BILL'S SHELL SERVICE STATION

Prompt Road Service

Union & Springfield Aves. New Providence, N. J.

SADIE THOMPSON

Toys - Notions - Greeting Cards

Springfield Ave. Berkeley Heights, N. J.

AREA ADVERTISEMENTS, 1948. This page of local advertisements appeared in a booklet entitled *Modern Pilgrims*, published by the Diamond Hill United Methodist Church, known at the time as the Diamond Hill Community Church (Methodist). The brochure tells the story of the first years of the church and also contains several pages of advertisements for businesses in town and surrounding locations, including Plainfield, a popular shopping destination at the time. (The Diamond Hill United Methodist Church.)

Three
ON STAGE AND SCREEN

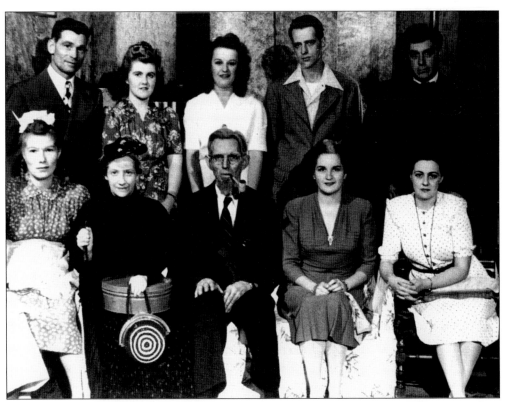

COMMUNITY HOUSE PLAYERS, C. 1940. The cast of *Mr. Bean from Lima* includes, from left to right, the following: (first row) unidentified, Mildred Burgmiller Shaffer, Leland Newcombe, DeeDee Cummings, and Helen Legg (Mildred Shaffer's sister); (second row) George Galla, Margaret Luce, ? Erickson, Dick Clay, and Bert Rogers. *Mr. Bean from Lima* was the first play presented by local residents at the Community House, which remains on Plainfield Avenue as a two-family home. (Gail Shaffer.)

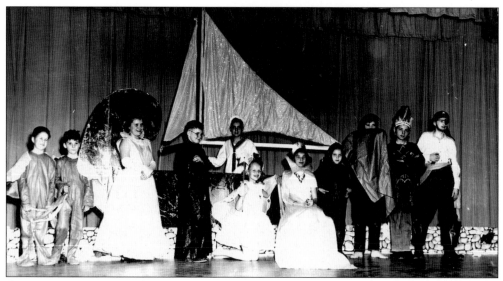

COLUMBIA SCHOOL ON STAGE, C. 1950. All grades participated in the school musical *Story Book Land*. The students include Gail Shaffer (third from left), Richard Wilson (the sailor, center), Johnny Stafford (second from right), and David Hoeterling (far right). After graduating from eighth grade at Columbia, most township students at this time continued their education at Jonathan Dayton Regional High School in Springfield. (Gail Shaffer.)

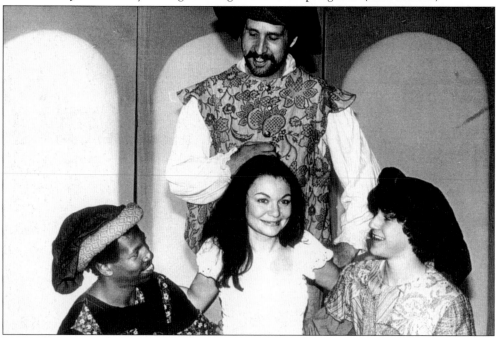

KISS ME, KATE, 1979. Founded in Berkeley Heights in 1945, the Stony Hill Players presented dramas and musicals in local venues until 1969, when the group moved to the old Union Village Methodist Church in Warren, just across the Berkeley Heights border. The players remained in Warren until the building was sold by the church in 1983. Shown in a scene from the Cole Porter musical are, from left to right, the following: (front) Stephen Smith, Roberta Porzillo, and Stephen Hirsch; (back) Thomas K. Freulen. (Stony Hill Players.)

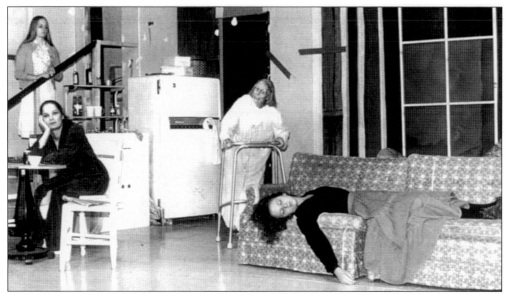

ON STAGE, 1979. Stony Hill Players rehearse a scene from Paul Zindel's *The Effect of Gamma Rays on Man-in-the-Moon Marigolds*. From left to right are Jana Rosenberger (Tillie); Judith Allwyn (Beatrice); Jane Hall (the Nanny), who lived in Free Acres for many years; and Jennifer Joyce (Ruth). After years of moving from one area stage to another, the Stony Hill Players found a permanent home in 2004 at the Oakes Memorial Center (formerly the Oakes Memorial Methodist Church), at 120 Morris Avenue in Summit. (Stony Hill Players.)

COMMUNITIES ON CABLE, C. 1988. Rosemary Knapp (second from left), a Governor Livingston High School graduate, and host Jean Manley (seated at right), a former local resident, await the make-up artists' final touches before showtime. On the show, Knapp discussed her experiences with the Peace Corps in South America. Joan L. Rotondi produced this show and many others for TV-36 in the series *Spotlight on Berkeley Heights*. (Joan L. Rotondi.)

PROJECT GRADUATION, C. 1990. Berkeley Heights resident Andrea Richel (right), host of many Berkeley Heights and Union County programs for TV-36, talks with Parent-Teacher Association members Kathy Fischbeck (left) and Ruth Siksnius about plans and fund-raising activities for the 1991 senior class graduation celebration at the high school. (Joan L. Rotondi.)

THE CHAMBERS OF COMMERCE TV-36 SHOW, C. 1992. A group pauses before discussing the many facets of the Suburban Chambers of Commerce. From left to right are Bob McManus (owner of the Door Boy Company, on Springfield Avenue), Denise Torsiello, host Andrea Richel, Josephine Ciullo, and Pam Donington Steiner. (Joan L. Rotondi)

"It's Beginning to Look a Lot Like Christmas," c. 1995. Leona Roll (left) and TV-36 host Andrea Richel review plans for a Communities on Cable segment on decorating for the holiday season. Mrs. Roll is the owner of Berkeley Florist and Garden Center, on Springfield Avenue, a business that she and her husband, Charles, opened on December 1, 1945. (Joan L. Rotondi.)

A Television Debut, 1994. Sarah Rogers, a student at Mountain Park School at the time, volunteers for Communities on Cable by making a public-service announcement for TV-36, on location in her home. The studios are located at the Central Presbyterian Church in Summit, and the shows cover the communities of Berkeley Heights, Millburn–Short Hills, New Providence, Springfield, and Summit. (Joan L. Rotondi.)

FIRSTHAND VIEWING, SEPTEMBER 16, 1994. A group waits for the start of *Nothin's Stoppin' 'Em*, a TV-36 show presenting an overview of the many activities of the Berkeley Heights Senior Citizens' Club. From left to right in the first row are Jean Schaeffer, Ann Garbarino, and Catherine Martino. Other audience members include, in the second row, Ruth and Al Merrill (right); and in the third row, Theodore "Pat" England (right), former mayor of Berkeley Heights. (Joan L. Rotondi.)

TOP SHOW, JULY 6, 1995. Joan L. Rotondi (center), TV-36 producer for Berkeley Heights, is all smiles after receiving the national Hometown Video Award in Boston for her show on the local senior citizens, *Nothin's Stoppin' 'Em*. Standing with her at Anthony's Pier 4 Restaurant in Boston are, from left to right, David Hawksworth, station manager for TV-36; Mrs. Rotondi's husband, Al Rotondi; Anthony Athenes, restaurant owner; and Valerie Brewster, local resident and TV-36 volunteer. Although Joan Rotondi no longer lives in town, she still produces a series of TV-36 shows entitled *The Total Picture*. (Joan L. Rotondi.)

SPEAKING OF EDUCATION ON TV-36, FEBRUARY 23, 1996. Andrea Richel leads a panel discussion on Union County Regional High School District No. 1 (Governor Livingston in Berkeley Heights, Jonathan Dayton in Springfield, Arthur L. Johnson in Clark, and David Brearley in Kenilworth). With Richel are, from left to right, William J. Van Tassel (board of education business administrator and board secretary), James L. Kirtland (board of education member), and Dr. Robert T. Stowell (superintendent of schools). (Joan L. Rotondi.)

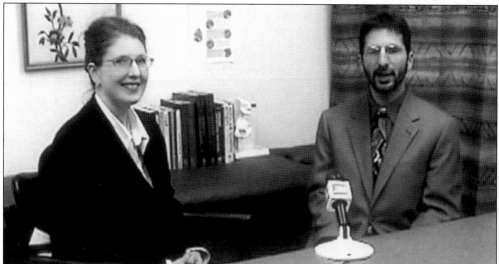

A HEALTH UPDATE, C. 2004. Dr. Donald C. DeFabio (right), who succeeded Joan L. Rotondi as the producer of the *Spotlight on Berkeley Heights* shows, discusses Lyme disease with Dr. Jeannine Baer at the television studio. DeFabio and Baer are local chiropractors with offices on Springfield Avenue. (Dr. Donald C. DeFabio.)

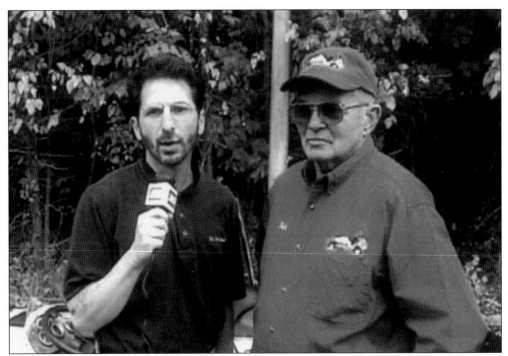

INTRODUCING *PHYLLIS*, C. 2004. Dr. Donald C. DeFabio (left) interviews Berkeley Heights resident Dick Briggs about *Phyllis*, an antique midget racing car. Briggs, who restored the car, worked as the original mechanic and crew chief in the 1950s and 1960s. Briggs purchased *Phyllis* in 1988 and spent over 18 months restoring it to original racing condition. Many well-known racecar drivers drove *Phyllis* to victories, and the car won an Antique Automobile Club of America National Award in 2000. Midget cars use methanol fuel and have no key or starter. The cars must be push-started by a truck. (Dr. Donald C. DeFabio.)

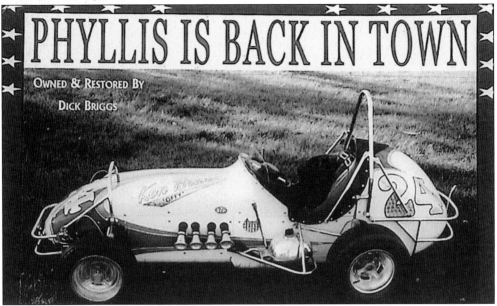

Four
FACES AND PLACES

THE PASTORAL PASSAIC, C. 1900. According to *The Diary of Betsey Crane*, 19th-century settlers transported lumber on scows and rafts along the river to a sawmill in West Summit, near Chatham. The settlers also enjoyed ice-skating on the river. Betsey Crane lived on a farm on Springfield Avenue with her large family, and kept a diary of her daily life from 1824 to 1828. (Berkeley Heights Historical Society.)

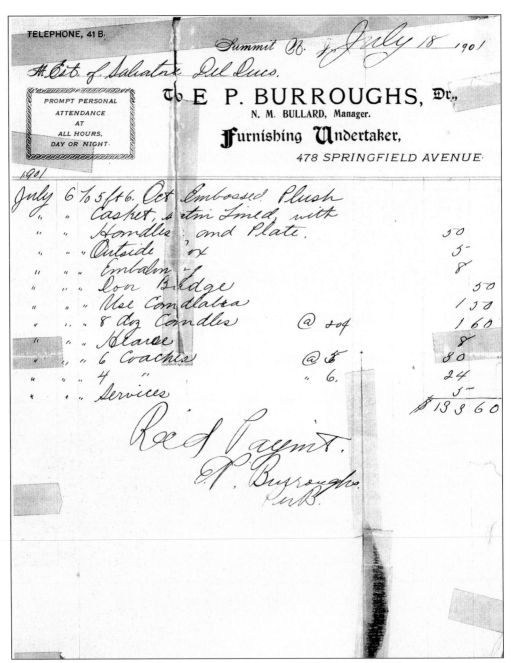

A FUNERAL BILL, 1901. This handwritten bill, sent to the family of Salvatore Del Duca of Berkeley Heights by Burroughs "Furnishing Undertaker" of Summit, presents a clear picture of funeral expenses at the dawn of the 20th century. Burroughs continues in business on Springfield Avenue in Summit as the Bradley-Brough Funeral Home. (Fred Gizzi.)

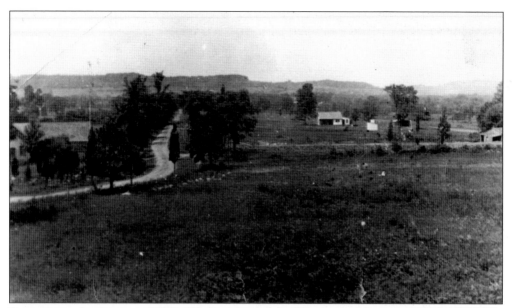

PLAINFIELD AVENUE, C. 1900. With a view of the Watchung Mountains in the distance, St. Mary's Stony Hill Roman Catholic Church can be seen on the left side of the narrow, dusty road that winds its way past the scattered houses and farms that make up the Berkeley Heights section of the township of New Providence. Plainfield Avenue was the main north–south artery in Berkeley Heights from as early as 1845, when the road was indicated but not named on an area map. (Mary Lou Weller.)

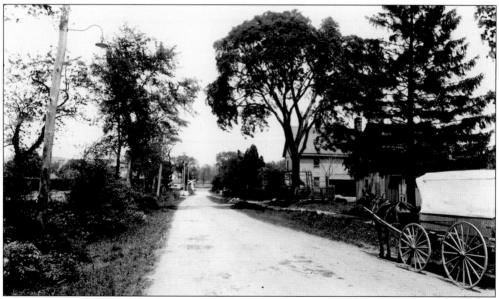

PLAINFIELD AVENUE, C. 1910. A shiny horse and well-kept buggy await their owner along the dirt road. Trains first came to Berkeley Heights around 1872, when the New Jersey West Line Railroad began operating with a stop at the Ellendor Station on Snyder Avenue. William A. L. Ostrander, a freeholder from New Providence, established the Ellendor Station, which he probably named for his daughter. Later, a political rival of Ostrander built a station near Plainfield Avenue called Berkeley Heights, and the Ellendor stop was abandoned. (Fred Gizzi.)

THE OUTING CLUB, C. 1925. For several years, German Americans from Newark and New York City enjoyed outdoor activities at this small compound of buildings, known as the Camptown Outing Club. It was located along the Passaic River near Kuntz Avenue and Camptown Drive. Before the automobile allowed people to travel longer distances to vacation spots, Berkeley Heights and the surrounding localities were popular destinations for people escaping the heat of the cities in summer. (Fred Gizzi.)

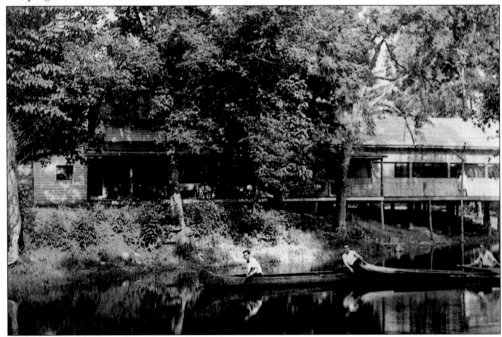

A POPULAR PAVILION, C. 1925. Keller's Grove, once known as Davis Osborn's, was a familiar picnic and barbecue spot, tavern, and boat dock along the Passaic River near Kuntz Avenue. (Mary Lou Weller.)

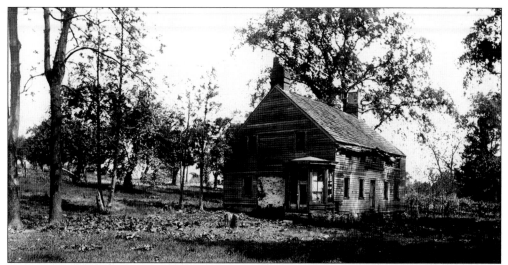

THE OLD HOMESTEAD, C. 1925. This lonely skeleton of an early Berkeley Heights house (the Cole-Ostrander home) was located in the vicinity of Lone Pine Drive. Built in the early 1800s by Elias Cole, it was later owned by freeholder William A. L. Ostrander, who, in addition to his railroad interests, established a local post office. (Fred Gizzi.)

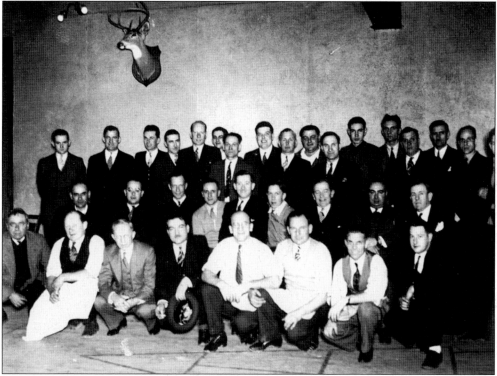

THE GUN CLUB, C. 1940. According to longtime resident Gail Shaffer, this club brought together men and boys from all parts of the township who shared an interest in firearms and hunting. The club probably met at the Community House on Plainfield Avenue. Included in this photograph are Ben Delia, Ernie Radzio, Clifford Shaffer, Al Hahn, Ed Botee, Harold "Haxie" Curtis, and police chief Dominick V. Russo. (Gail Shaffer.)

A HAPPY COUPLE, C. 1970. Peter and Rose Romano smile on the occasion of their 50th wedding anniversary. The Romanos raised 11 children at their family homestead, which still stands at 559 Springfield Avenue. (Mary Lou Weller.)

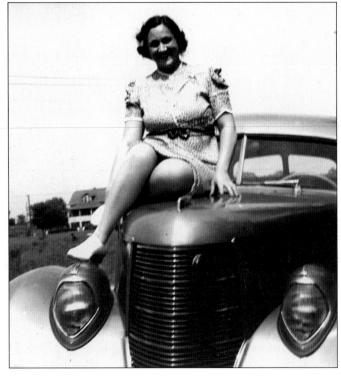

MARGARET ROMANO LANDWEHR, C. 1940. One of Peter and Rose Romano's daughters, Margaret, grew up at 559 Springfield Avenue, and married Frank Landwehr of Stirling. During the Great Depression year of 1932, Pres. Herbert Hoover said, "Buy an automobile, and help restore prosperity." Automobiles were valued possessions for many families, and Margaret was surely proud to pose on the hood of this 1938 Studebaker. (Mary Lou Weller.)

A FAMILY BUSINESS, APRIL 16, 1945.
Peter Romano Jr., wife Marcille, and children Peter and Peggy stand with their truck, which advertises the family business, Romano's Home Insulation and Roofing Company. The business was located on Berkeley Avenue, near where the YMCA is located today. A 1948 local advertisement listed such company services as siding, sheet metal, roofing, home insulation, and blown-rock construction. (Mary Lou Weller.)

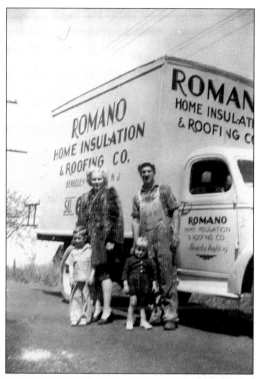

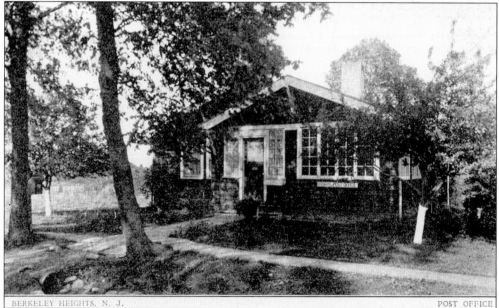

A LASTING LANDMARK, C. 1925. This vintage postcard shows the Berkeley Heights post office, located on the front porch of 320 Plainfield Avenue, the home of Clarence Curtis, township postmaster from 1925 to 1935. The post office relocated several times after 1935; in 1960, it moved to its present location on Springfield Avenue. Michael Nigro became postmaster in 1940 and served until his death in 1968. The Curtis home remains a private residence. (Berkeley Heights Historical Society.)

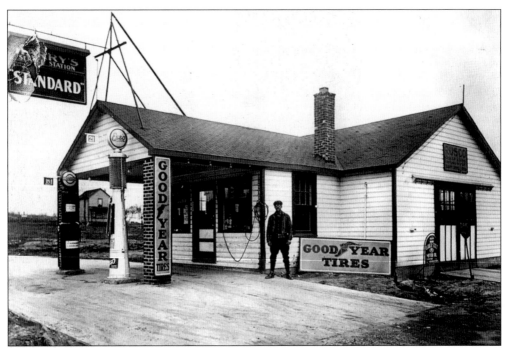

A Service Station through the Years, 1928. Berkeley Heights resident Harry E. Kern Sr. stands proudly in front of his new gas station and garage, Harry's Service Station. The station was located at the intersection of Union and Springfield Avenues on the Berkeley Heights–New Providence border. Esso gasoline in 1928 was certainly a bargain, selling for 18¢ and 21¢ a gallon. (Township of Berkeley Heights.)

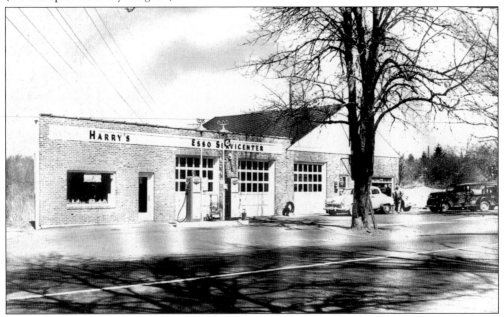

Harry's Service Station, March 1949. At this time Harry Kern had moved his full-service center directly across Springfield Avenue in New Providence. Post–World War II gas prices, at 23¢ and 25¢ a gallon, were still low. (Township of Berkeley Heights.)

HARRY'S, 1960.
Harry's has become a
Mobil station on a
now-treelined
Springfield Avenue.
Plaid Stamps are being
offered as a sales
incentive. (Township
of Berkeley Heights.)

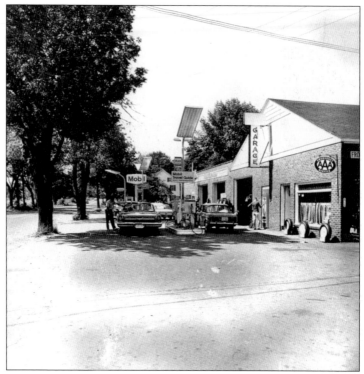

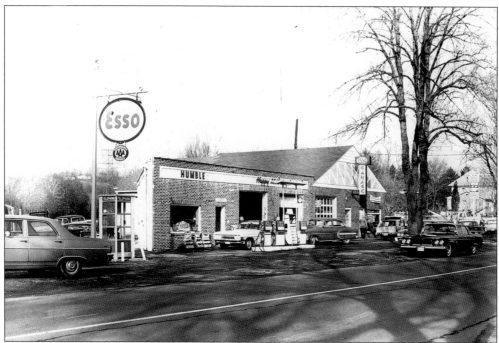

HARRY'S, DECEMBER 1966. It looks like a busy day at the garage, which has changed back to Esso gasoline, now distributed by the Humble Oil Company. At some point over the years, Harry Kern's sons, Harry and David, joined the business. Today, Harry's is known as Bill's, a Citgo station. (Township of Berkeley Heights.)

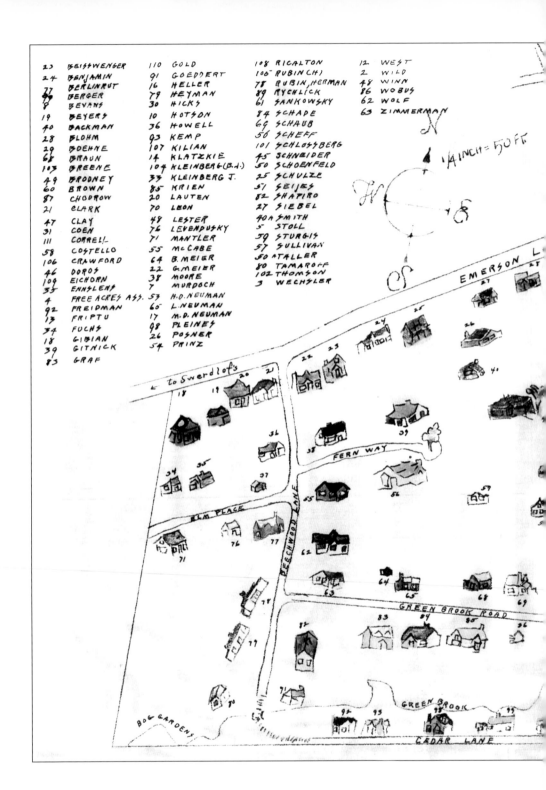

23	ZEISSWENGER	110	GOLD	108	RICALTON	12	WEST
24	BENJAMIN	91	GOEDDERT	100	RUBIN (CH)	2	WILD
77	BERLINRUT	16	HELLER	78	RUBIN, HERMAN	48	WINN
44	BERGER	79	HEYMAN	89	RYCHLICK	86	WOBUS
9	BEVANS	30	HICKS	61	SANKOWSKY	62	WOLF
19	BEYERS	10	HOTSON	84	SCHADE	63	ZIMMERMAN
40	BACKMAN	36	HOWELL	69	SCHAUB		
28	BLOHM	93	KEMP	56	SCHEFF		
29	BOEHNE	107	KILIAN	101	SCHLOSSBERG		
68	BRAUN	14	KLATZKIE	45	SCHNEIDER		
103	GREENE	104	KLEINBERG (B.J.)	50	SCHOENFELD		
49	BRODNEY	33	KLEINBERG J.	25	SCHULZE		
60	BROWN	85	KRIEN	51	SEIJES		
87	CHODROW	20	LAUTEN	82	SHAPIRO		
21	CLARK	70	LEON	27	SIEBEL		
47	CLAY	48	LESTER	40A	SMITH		
31	COEN	76	LEVENDUSKY	5	STOLL		
111	CORRELL	71	MANTLER	59	STURGIS		
58	COSTELLO	55	McCABE	57	SULLIVAN		
106	CRAWFORD	64	B. MEIER	50A	TALLER		
46	DOROS	22	G. MEIER	80	TAMAROFF		
109	EICHORN	38	MOORE	102	THOMSON		
35	EMNSLENS	7	MURDOCH	3	WECHSLER		
4	FREE ACRES ASS.	53	H.O. NEUMAN				
92	FREIDMAN	65	L. NEUMAN				
13	FRIPTU	17	M.O. NEUMAN				
34	FUCHS	98	PLEINES				
18	GIBIAN	26	POSNER				
39	GITNICK	54	PRINZ				
83	GRAF						

¼ INCH = 50 FT

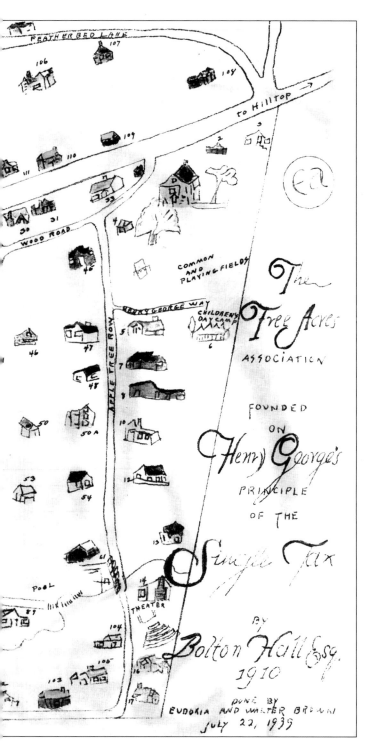

FREE ACRES, 1939.
Located off Emerson Lane
in the southwestern corner
of the township, the
single-tax community of
Free Acres was established
in 1910. This unique map,
drawn by an early Free
Acres couple, Eudoria and
Walter Brown, lists their
fellow residents and
indicates the location of
their homes. Today, Free
Acres remains one of two
communities in the
United States to practice
the single-tax philosophy
advocated by American
economist Henry George
(1835–1897). The other
town is Arden, Delaware.
(Jeff Diamond.)

THE ENTRANCE TO THE CONNER RESIDENCE, 2003. Hazel and Terrence Conner live in this house on Water Lane in Free Acres. Terrence Conner's grandfather, Thorne Smith, was the original leaseholder of the property in 1920. While at Free Acres, Smith was inspired to write the first of his popular novels about Cosmo Topper, a banker and New Jersey resident, whose ordinary life is turned upside-down when he finds himself in a world of whimsically comical ghosts. *Topper* was published in 1926 and was followed by several sequels and movies. (Terrence D. Conner.)

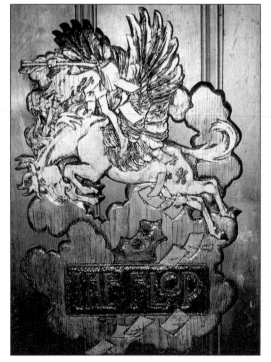

THE "FLOP," 2004. When Thorne Smith mentioned to Free Acres artist and resident Will Crawford that he was sure his forthcoming novel *Topper* would be a flop, "Uncle Will" proceeded to create this intricate, one-of-a-kind woodcarving, which depicts Smith heading for a flop from the winged horse, Pegasus, with the pages of his new book flying over his head. Crawford also carved many street signs for the Free Acres community. (Terrence D. Conner.)

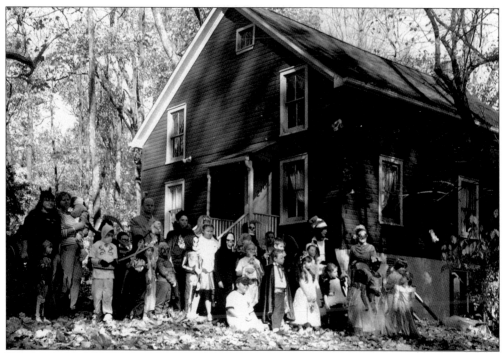

TRICK OR TREAT, 2004. Youngsters gather on Halloween outside the historic Free Acres Farmhouse, which is a Union County historical landmark. The meeting hall inside is named for Frank Stephens, an avid single-tax advocate. The farmhouse, which dates from 1820, became part of Free Acres in 1910. Previous owners included such family names as Wilcox, Cager, Dobson, Sowden, and Murphy. (Laurel and Sigmar Hessing.)

A FREE ACRES PATHWAY, 2004. Century-old trees line the woodland trails of the community. Although many of the original cottages have been enlarged and remodeled, the residents remain committed to preserving the natural environment and have always enjoyed the outdoors. In 1912, the Free Acres Open Air Theater presented *Hiawatha* on evenings when the moon was full. Other summer productions and musicals with outdoor illumination followed, until World War II blackouts brought an end to the theatricals. (Terrence D. Conner.)

FREE ACRES ROADS, PATHS

FA paths:
- **1** between Apple Tree Row and Greenbrook Road
- **2** between Cedar Lane and Beechwood Road
- **3** between Greenbrook Road and Water Lane

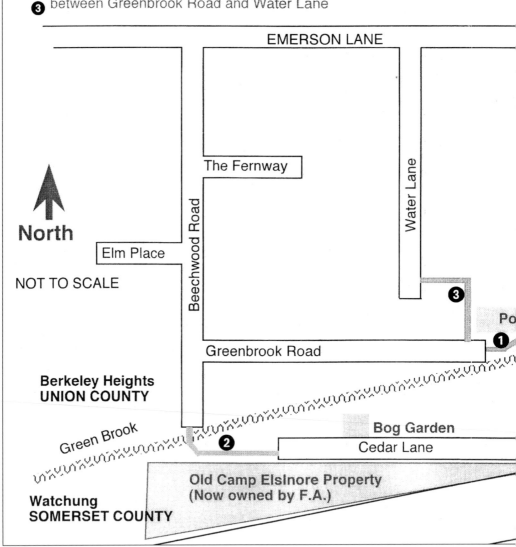

EMERSON LANE

The Fernway

Water Lane

Beechwood Road

North

Elm Place

NOT TO SCALE

3

Po

Greenbrook Road

1

**Berkeley Heights
UNION COUNTY**

Green Brook

Bog Garden

2

Cedar Lane

**Old Camp Elsinore Property
(Now owned by F.A.)**

**Watchung
SOMERSET COUNTY**

ЭMMON LAND

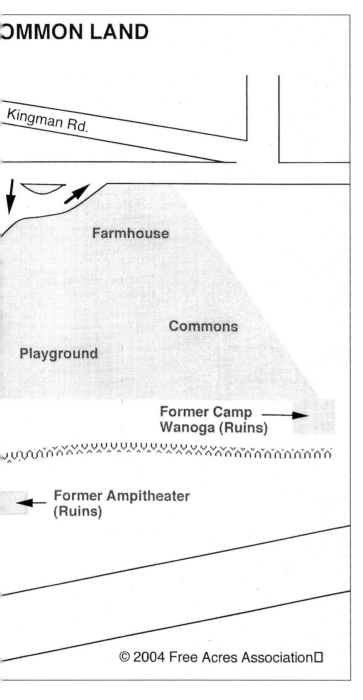

Kingman Rd.

Farmhouse

Commons

Playground

Former Camp Wanoga (Ruins)

Former Ampitheater (Ruins)

© 2004 Free Acres Association☐

FREE ACRES, 2004. This recent map, created by Free Acres resident Harris Ruben, indicates that Free Acres has not changed in any major way from earlier times. Camp Wanoga (right center) was a day camp for Free Acres children, where Harold Breene served as a counselor. Breene has continued his early interest in camping as the owner of the well-known children's day camp, Camp Riverbend, on Hillcrest Road in Warren. Camp Elsinore (lower left) was opened by Dr. Richard Moldenke as a summer camp for the German immigrant children who were left orphans when their parents were among the 1,000 people drowned on the *General Slocum*, an excursion boat that sank in New York Harbor on January 26, 1904. Moldenke, a world-famous cast-iron metallurgist, is remembered for the medieval-style castle (also named Elsinore) that he built nearby in Watchung in 1900. The castle was razed around 1970. (Harris Ruben and the Free Acres Association.)

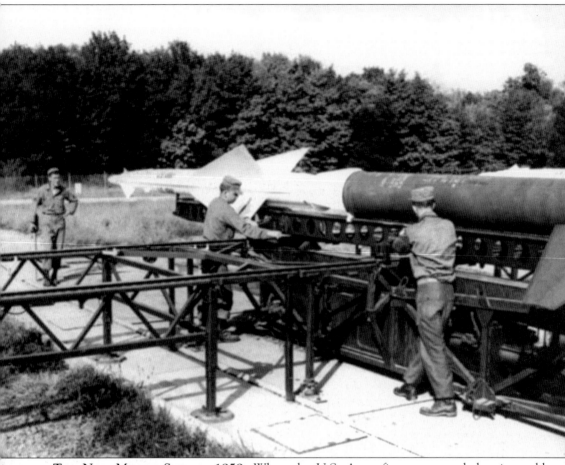

THE NIKE MISSILE SITE, C. 1959. When the U.S. Army first announced that it would construct a Nike missile site in the Watchung Reservation, Union County officials and area residents strongly protested. The missile base was finally completed in 1958, but less than four years later, the army began deactivating the site. This image shows crewmen working on a Nike Ajax missile at the launcher area located on Summit Lane, where the Watchung Stables now stand. Only a few foundation remnants and portions of the original wire-topped fences remain at the control center next to Governor Livingston High School. The army's original access road leading to this site from Glenside Avenue is now used by local runners and bicyclists but is closed to motor traffic. During the autumn of 1962, the underground cables connecting the control and launcher areas were severed only days before the Cuban missile crisis. (U.S. Army–Redstone Arsenal and Don Bender.)

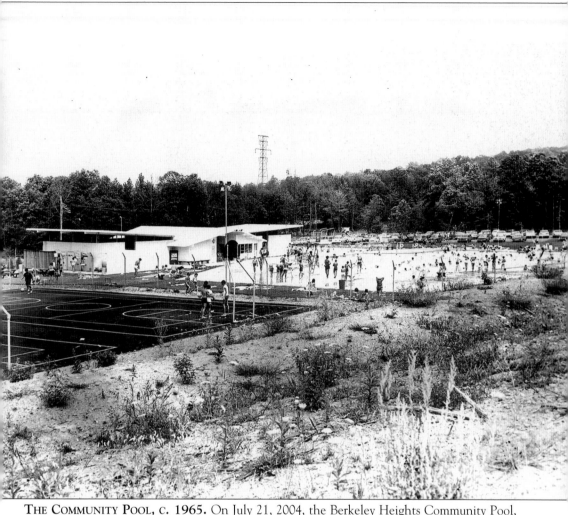

THE COMMUNITY POOL, C. 1965. On July 21, 2004, the Berkeley Heights Community Pool, on Locust Avenue, celebrated its 40th anniversary. Pool memberships have doubled from 400 families in 1964 to over 800 in 2004. A township pool was first proposed in October 1963, when a group of residents formed a corporation. Ernest Prupis, William Benson, Herbert Marks, and Lois Matarese were elected as the first officers. Others involved in the project through the years have included Warren Roche, Helen Vance Levenson (editor of the *Berkeley Heights-New Providence Dispatch*), Gene Daniel, and Julian Rivo. Designed by Joseph Massimo and contracted by Sylvan Pools, the pool was similar to the New Providence Community Pool, which opened a few years earlier. In 2004, Arlene Platt served as the pool manager, and Joan Austra was the president of the board of trustees. Many improvements have been made through the years, with continuing plans for new and expanded facilities at this immensely popular community resource. (R. S. Kennedy, Township of Berkeley Heights.)

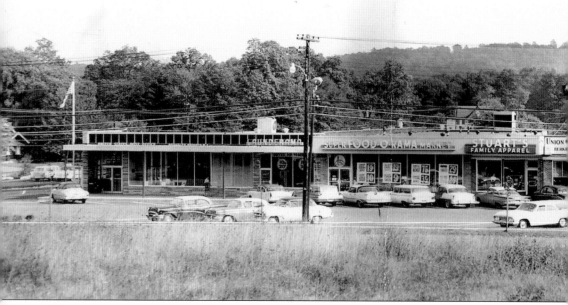

DOWNTOWN, 1960. It was almost one-stop shopping in town when this strip of stores on Springfield Avenue was built on open land owned by local resident Coney Mea. This photograph was taken from a field across the avenue, where professional offices were later built. The post office (far left) remains at the end of this strip. The Food-o-Rama (third from left) was

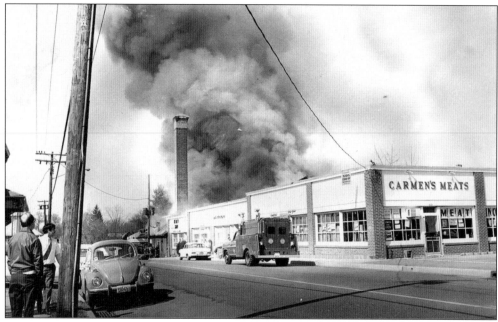

THE GARDEN STATE SWIM CLUB FIRE, 1974. Dark smoke billowed over Springfield Avenue from the fire at the swim club, located on Passaic Avenue behind this row of stores. The pool of the Garden State Swim Club, now the Berkeley Aquatic Club and Swim School, had been built inside the former Del Duca greenhouses on the property. (Township of Berkeley Heights.)

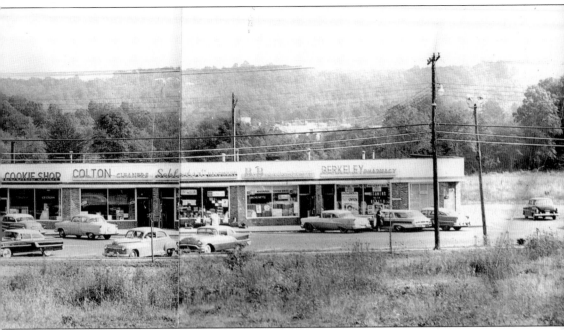

the first modern food store in town and burned down in the late 1960s. The shops that have changed through the years include the Colton Cleaners, which became Berkeley Cleaners; the B&B Luncheonette, now the Country Farms convenience store; and Berkeley Pharmacy (right), which is now Dunkin' Donuts. (Township of Berkeley Heights.)

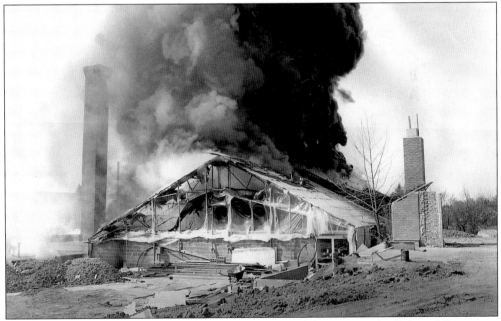

THE SWIM CLUB FIRE, 1974. The Garden State Swim Club was once the Delwood Recreation Center. At the time of the fire, the club was in the process of renovation. While workers were using torches to dismantle the old iron structure that framed the original greenhouse, the insulation caught fire. The facility was later rebuilt on the same location. (Township of Berkeley Heights.)

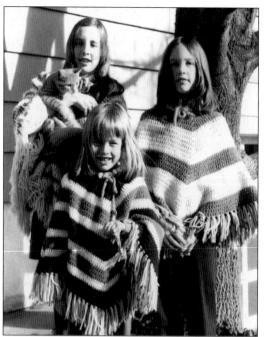

WHAT GOES AROUND, 1972. The Troeger sisters of Berkshire Drive, Cindy (holding Pumpkin), Joanne (center), and Janice were right in style at the time with their colorful, hand-crocheted ponchos, a fashion that later returned to favor. The poncho originated in South America in the early 1700s. (Virginia B. Troeger.)

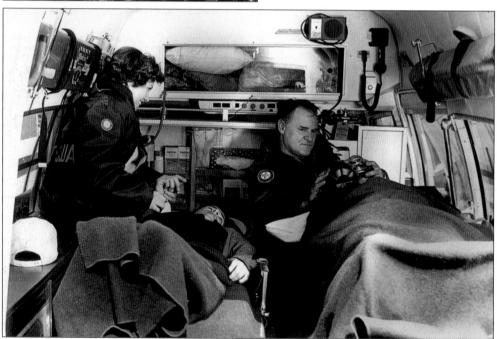

RESCUE SQUAD OPEN HOUSE, C. 1977. Squad member Bonnie Perry (left) and rescue squad captain Edward Damanski, with two students posing as the injured, demonstrate first-aid techniques inside the squad's old Cadillac ambulance. During the time that Damanski served as captain, he maintained control over the apparatus, directed the duties of squad members at first-aid calls and parades, supervised monthly practice drills, and taught Red Cross first-aid courses to residents, schools, and industries. The Berkeley Heights Rescue Squad was organized in 1942 and continues as a vital community service. (Township of Berkeley Heights.)

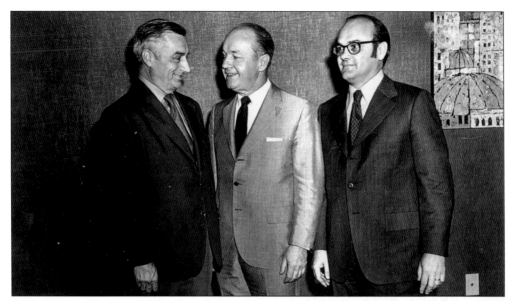

A TOWNSHIP TRIO, C. 1982. From left to right are Berkeley Heights mayors Theodore "Pat" England, Anton C. Swenson, and William Smith. Swenson served as mayor from 1939 through 1943 and again in the 1950s. England held the office in 1968, 1971, and 1973. Smith, who served as mayor in 1978 and 1983, was also employed as township administrator at another time. (Township of Berkeley Heights.)

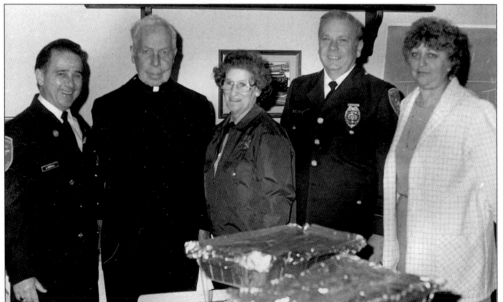

MEMORIAL MASS ATTENDEES, MAY 5, 1987. A memorial Mass is held every May at the Church of the Little Flower to honor the township's deceased police officers, firefighters, rescue squad members, and school crossing guards. Seen at this memorial Mass are, from left to right, volunteer firefighter Joseph Cerulli; Fr. Joseph P. Fagan, pastor of the Church of the Little Flower; crossing guard Lillian Masullo; Chief Ralph Del Duca of the police department; and Carol Imbimbo, president of the ladies' auxiliary of the township fire company. (Township of Berkeley Heights.)

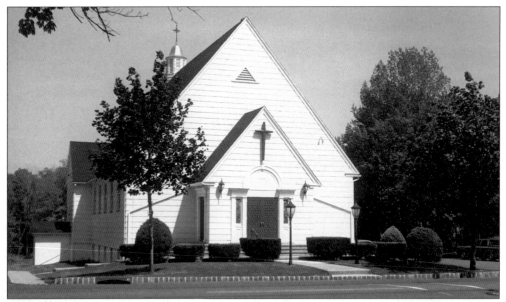

THE CHURCH OF THE LITTLE FLOWER, C. 1995. This Plainfield Avenue building, known as the Little Church, was dedicated on October 26, 1930. It opened on a regular schedule for Sunday Mass at that time, but did not have a resident pastor until 1955. The parish patroness is St. Therese of the Child Jesus and the Holy Face (the Little Flower). Therese was a French nun who died at the age of 24. She was declared a saint in 1925. (Joan L. Rotondi.)

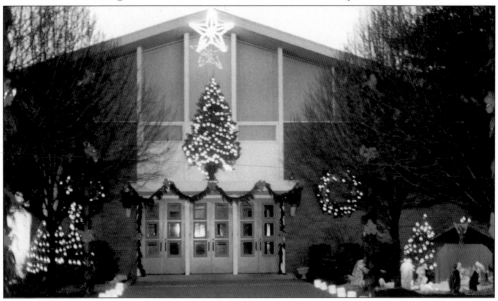

THE LITTLE FLOWER AUDITORIUM, C. 2000. Plans for the auditorium, a convent, and a school on Roosevelt Avenue began in the late 1950s, at a time of great growth within the parish. The first classes were held in Little Flower School in September 1963, and the first eighth-grade class graduated in 1968. The school closed in 1988 because of declining enrollment. Little Flower parish celebrates two important milestones in 2005—the 75th anniversary of the dedication of the Little Church and the 50th anniversary of the incorporation of the parish. (The Church of the Little Flower.)

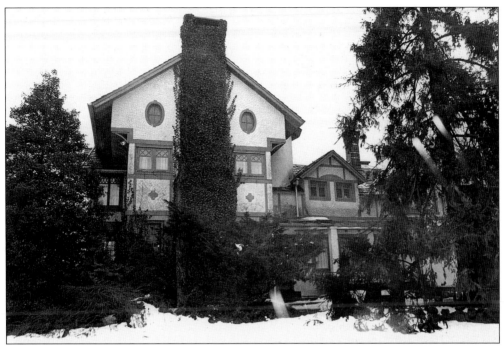

PARK AVENUE LANDMARKS, 1985. The Creveling House (above) was saved from demolition in the 1980s through the dedication of local residents who recognized its unique Tudor-picturesque style. However, the two-story barn (below), which also contained many unusual architectural details, was demolished in 1985 to make way for a new development of seven homes on the property, which is now called Magnum Court. Built around 1915, the house was owned by Laela Albertina Creveling, a widow and New York City feminist, who is credited with organizing the first Parent-Teacher Association in Berkeley Heights. (Berkeley Heights Historical Society.)

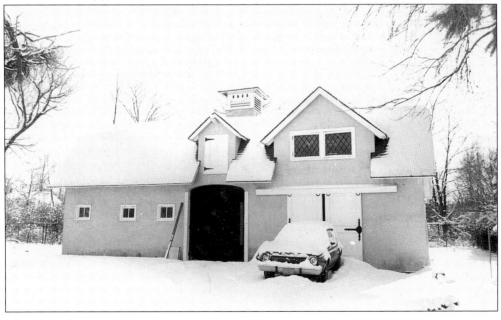

THE FALLS AT SEELEY'S POND, 1973. Equally divided between Berkeley Heights and Scotch Plains, the Falls at Seeley's Pond, off Diamond Hill Road, were named for Edmund A. Seeley, a Scotch Plains businessman who in the late 1800s founded a paper-manufacturing company that used the falls for power. Seeley lived in a large Victorian home in the Watchung Mountains above Seeley's Pond. This homestead was later demolished. According to local history accounts, Gen. George Washington turned back the British forces at this spot, known as Bloody Gulch (or Bloody Gap), during the Battle of the Short Hills on June 26, 1777. Washington's troops sent the redcoats in retreat to Perth Amboy. Along the way, the British troops burned farms and homes in the Westfield-Woodbridge area. The American soldiers were carrying the first national American flag, which was adopted by the U.S. Congress on June 14 under the First Flag Act. If the story is true, the new official Stars and Stripes was fired upon for the first time at this spot. (Berkeley Heights Historical Society.)

Five
SPECIAL TIMES

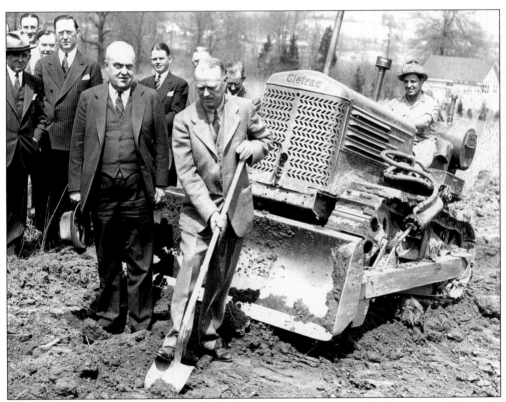

RIVER BEND GROUNDBREAKING, APRIL 17, 1941. Mayor Anton C. Swenson (holding the shovel) formally breaks ground for the new River Bend development of homes off Park Avenue. With hat in hand, Mayor Guido Forster of Summit stands beside him. Others attending the ceremonies included township recorder Joseph Mulholland, New Providence mayor John Oakwood, and New Providence supervising principal of schools Eugene L. Miller. (*Courier-News*, Township of Berkeley Heights.)

THE FIRE COMPANY STEPS OUT, JUNE 1943. Preparing for a dress parade in front of their headquarters next to town hall on Park Avenue, local volunteer firemen celebrate the company's 15th anniversary. Standing next to the first fire truck (left) to be owned by the company is foreman Xavier Masterson, and seated in the truck are assistant foreman John Romano (left) and retired fire chief John Amodeo. Standing at the newer truck (right) is assistant chief Carl Carpenter, and seated in it are township mayor and president of the fire company Anton C. Swenson (left) and fire chief Anthony Amodeo. (Berkeley Heights Historical Society.)

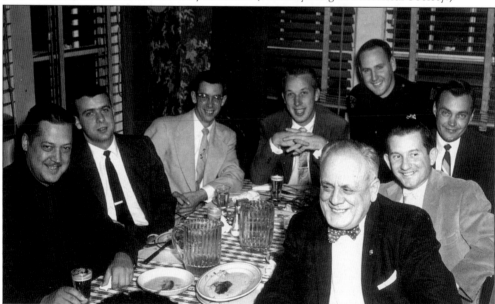

A GATHERING OF TOWN FATHERS, NOVEMBER 16, 1958. Enjoying an evening out at a local restaurant are, clockwise from lower left, Luther Smythe, Ralph Del Duca, Al Christensen, George Siter, Larry Benner, Charles LaSecla, Al LaJeunesse, and Salvatore Mazzarisi. Township officials, policemen, and firemen are represented at the table. (Township of Berkeley Heights.)

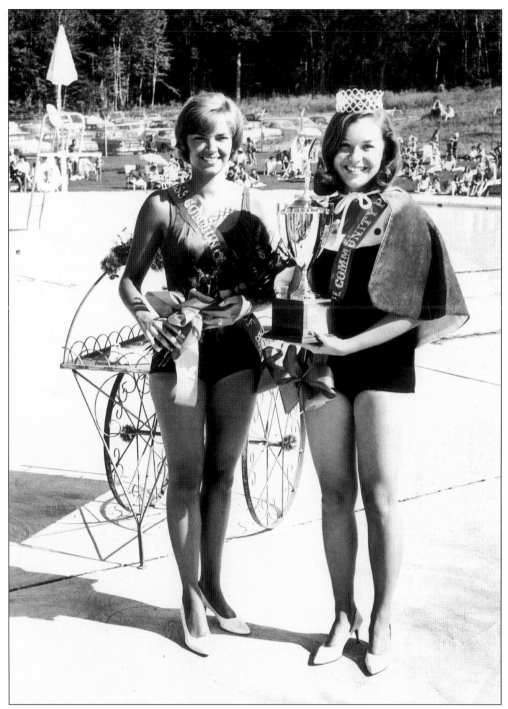

COMMUNITY POOL BEAUTIES, SEPTEMBER 1965. Sixteen-year-old Susan Spratt (right) was crowned Miss Community Pool at a Labor Day parade and celebration held at the pool on Locust Drive. Standing with her is Beth Van Ness, who had received the title in 1964, the year the pool opened. Swimming competition awards were also presented at this time. (R. S. Kennedy, Township of Berkeley Heights.)

A Mount Carmel Celebration, July 16, 1924. Margaret Romano (right) is one of the township girls participating in the procession to Old St. Mary's Stony Hill Church on Plainfield Avenue, where a Mass was celebrated. The Mount Carmel Society was founded in the early 1900s by Springfield Avenue resident Maria Venezia to commemorate Our Lady of Mount Carmel. July 16 is the saint's feast day. (Mary Lou Weller.)

Decorating Our Lady, July 15, 1996. Vito Mondelli arranges the floral displays around the statue of Our Lady of Mount Carmel in preparation for the annual procession. Maria Venezia became ill during childbirth and experienced a vision of the Virgin Mary. She made a promise that if Mary would help her and her baby survive, she would celebrate the saint's day every year. Venezia safely gave birth to a baby daughter and carried out her promise to honor Our Lady for helping her and for helping Italian immigrants survive their trip to America. (Joan L. Rotondi.)

HONORING OUR LADY, 1994. Many of those attending the Mount Carmel procession continue the long tradition of pinning donations on the statue of Our Lady. Contributors receive a scapular with images of Our Lady of Mount Carmel and Simon Stock, an English saint living in the 13th century whose patroness was the Virgin Mary. In the early days, when the society was made up of women, Maria Venezia led the procession herself. Today the Mount Carmel Society is an organization of men. (Joan L. Rotondi.)

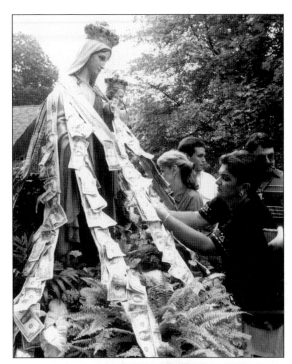

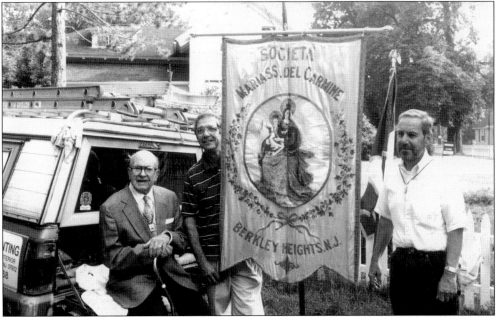

A TREASURED SYMBOL, JULY 1994. Dan Mondelli (left), Clem Manganelli (center), and Bill Manganelli display the original banner carried annually in the Mount Carmel procession. The banner is cared for by Clem Manganelli and is refurbished as needed. Today the parade begins at the Church of the Little Flower and continues past the homes of Mount Carmel Society members. Following an age-old Italian custom known as "Reports," fireworks are shot off at approved locations when the procession passes a member's home. Before a change in the fire-safety laws, the fireworks were shot off directly in front of each house. (Joan L. Rotondi.)

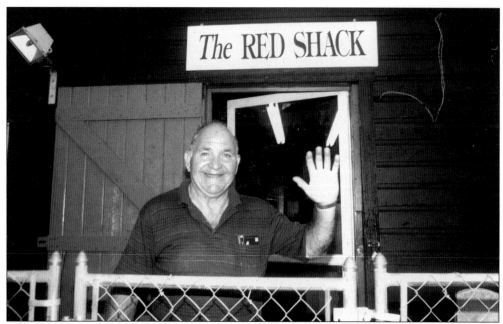

A FESTIVAL GREETING, 1996. Mount Carmel Society member Artie Salegna welcomes fairgoers from the door of the Red Shack on the Mount Carmel fairgrounds. During the week preceding the procession, the society sponsors a gala fair. On July 16, the last evening of the festival, crowds gather for the spectacular fireworks from Garden State Fireworks of Millington. The Mount Carmel Society contributes to the Church of the Little Flower and volunteer emergency units. The society also sponsors a Christmas toy drive for children in need, as well as a scholarship at Governor Livingston. (Joan L. Rotondi.)

A FORTHCOMING VISIT, JULY 1997. The township bulletin board, on the corner of Springfield and Plainfield Avenues, announces Gov. Christine Todd Whitman's visit to the Mount Carmel Festival. During her time in town, Whitman spoke briefly at Mount Carmel Hall and accepted a copy of a video celebrating famous New Jersey women. Presented by Mountain Park teachers Sherry Butler and Julia Donnelly, the video was the culminating activity for a research project by their fourth-grade classes. (Joan L. Rotondi.)

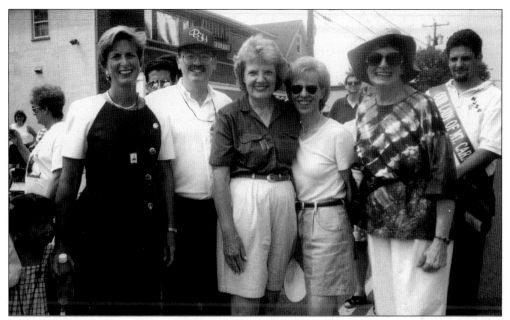

MARCHING WITH HER HONOR, JULY 16, 1997. This photograph was taken during the Mount Carmel procession down Springfield Avenue en route to the Church of the Little Flower. From left to right are New Jersey governor Christine Todd Whitman, Berkeley Heights mayor Daniel Palladino, Mountain Park teachers Julia Donnelly and Sherry Butler, Mountain Park librarian Virginia Troeger, and Mount Carmel Society member Brian Gagliardi. (Joan L. Rotondi.)

A FESTIVAL VISITOR, JULY 16, 2004. Rev. Joseph V. Derbyshire, formerly of Little Flower Church, enjoys the Mount Carmel procession as a spectator. (Joan L. Rotondi.)

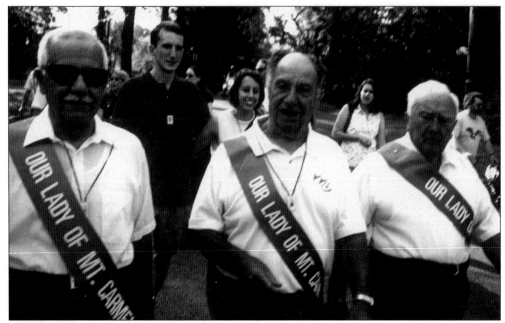

SOCIETY MEMBERS STEP OUT, JULY 16, 2004. Among a record crowd of marchers are, from left to right in the front row, Anton Delia, Sam Delia, and Gerard Cafaro. They are wearing the green banners that identify members of the Mount Carmel Society. After the procession and Mass at the Church of the Little Flower, participants and spectators gathered to enjoy traditional Italian food and music at nearby Peppertown Park. (Joan L. Rotondi.)

THE TREE OF WISDOM, JULY 16, 2004. Mount Carmel Society member Jerry DiPasquale smiles for the camera beside the township's best-known tree, which stands on Plainfield Avenue near the railroad station. For years, township men, and later their children and grandchildren, have gathered under this tree to discuss possible solutions for local and national problems. Some time ago, a sign mysteriously appeared that designated it as "the Tree of Wisdom." When that sign faded, a new one just as mysteriously replaced it. (Joan L. Rotondi.)

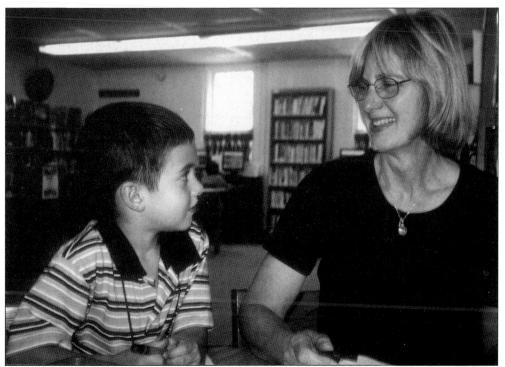

A LIBRARY VISITOR, JULY 16, 2004. Declan Feely (left), son of Martin Feely and Jean Rotondi Feely and grandson of former residents Al and Joan Rotondi, stops for a chat with Laura Fuhro, children's librarian at the Berkeley Heights Public Library, after viewing the Mount Carmel parade. (Joan L. Rotondi)

THE MOUNT CARMEL PICNIC, 1996. Longtime member Vincent Ferrara and his wife, Anna, were among many Mount Carmel Society families attending the annual members' picnic on the fairgrounds off Springfield Avenue. (Joan L. Rotondi.)

READY, SET, GO, 1995. Crissy Vicendese (left), a student at Mountain Park School, and her mother, Midge, are waiting to pedal off in a bike race sponsored by the Berkeley Heights Education Foundation. Organized by Berkeley Heights resident Marcia Miller in 1994, the foundation raises funds from individuals and businesses to finance innovative grant programs for the Berkeley Heights schools, and sponsors programs to encourage community involvement in the educational process. (Joan L. Rotondi.)

A GOOD DEED, OCTOBER 1997. Evan Finn (left) and Chris Pagano of Boy Scout Troop 268 give the bench in front of the public library a fresh coat of red paint as part of a Scout project. The first Boy Scout troop in town, Troop 68 was organized in the 1930s and met at Columbia School. It was followed in 1951 by Troop 168 at the Diamond Hill Methodist Church. (Joan L. Rotondi.)

LOCAL LADIES, OCTOBER 1997. Alice Keimel (left) and Pat Risden stop for a photograph at the St. Joseph's Craft Fair, held at the Berkeley Heights Community Center. Keimel has been a longtime volunteer with the Berkeley Heights Rescue Squad. She and her husband, Fred, were each honored for their community service as grand marshals of Memorial Day parades in the 1990s. Risden was employed as head dietician and patient advocate at Runnells Specialized Hospital and also served on its board of managers. (Joan L. Rotondi.)

THE EMERGENCY SERVICE AWARD, SPRING 1998. Howard Meyer (right), a member of the Berkeley Heights Volunteer Rescue Squad, receives the Overlook Hospital Area First Aid Council Recognition Award from Dr. James Itzcovitz, director of Overlook's emergency medical services, at the hospital's second-annual Excellence in Emergency Medical Services Awards Dinner. (*Berkeley Heights–New Providence Dispatch*, Township of Berkeley Heights.)

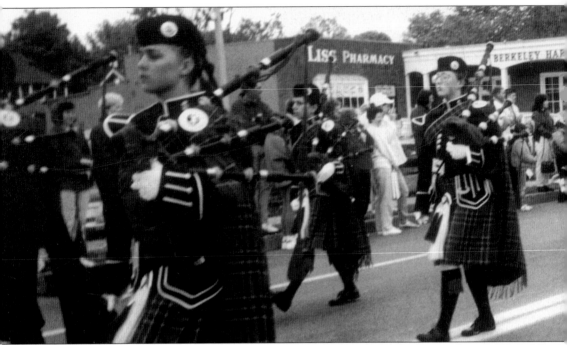

ON PARADE, C. 1996. The Governor Livingston High School band marches along Springfield Avenue during the Memorial Day parade. Through the years, the Highlander Band has won numerous national and international competitions and has made several summer trips to Edinburgh, Scotland. Since Gov. William Livingston's father, Robert Livingston, was originally

PARADE SPECTATORS, C. 1996. Berkeley Heights residents Rosemary Dean (left), Kerry Rotondi (center), and Dr. Maria Toft join the townsfolk gathered near town hall for cold drinks, hot dogs, cotton candy, popcorn, and pizza after the Memorial Day parade and commemorative service honoring local veterans of all wars. (Joan L. Rotondi.)

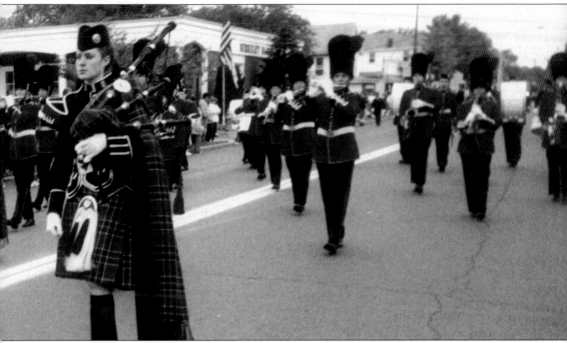

from Ancrum, Scotland, the high school adopted the Scottish Highland motif and Royal Stewart tartan. The band is easily recognized by the distinctive sound of the bagpipe. In 1996, the Highlanders visited Ancrum, a small Scottish town of less than 300 people, and met with local officials, residents, and the news media. (Joan L. Rotondi.)

PARADE HONOREE, C. 1996. Mayor Daniel Palladino (right) presents Carl Molinari with a plaque designating him as grand marshal of the Memorial Day parade and honoring his many years of service to Berkeley Heights. Molinari was the first letter carrier in Berkeley Heights, delivering mail to homes twice a day. (Joan L. Rotondi.)

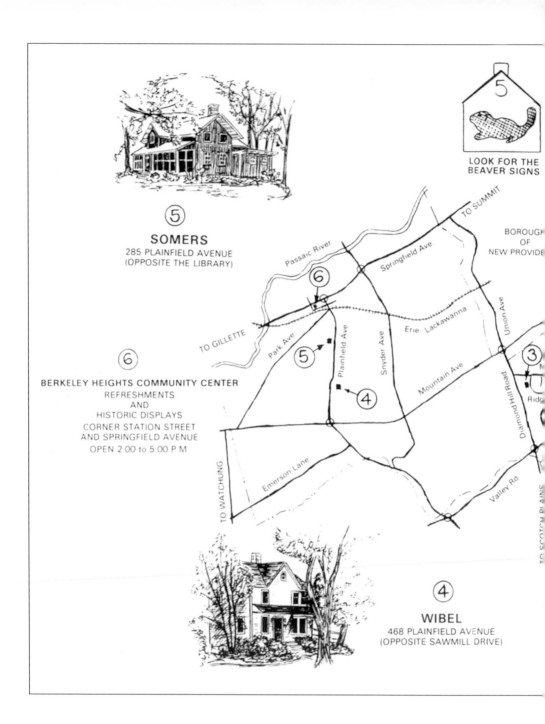

LOOK FOR THE
BEAVER SIGNS

⑤
SOMERS
285 PLAINFIELD AVENUE
(OPPOSITE THE LIBRARY)

⑥
BERKELEY HEIGHTS COMMUNITY CENTER
REFRESHMENTS
AND
HISTORIC DISPLAYS
CORNER STATION STREET
AND SPRINGFIELD AVENUE
OPEN 2 00 to 5 00 P M

④
WIBEL
468 PLAINFIELD AVENUE
(OPPOSITE SAWMILL DRIVE)

TO SUMMIT

BOROUGH
OF
NEW PROVIDE

Passaic River
Springfield Ave
TO GILLETTE
Park Ave
Plainfield Ave
Snyder Ave
Erie Lackawanna
Union Ave
Mountain Ave
Diamond Hill Road
Ridg
TO WATCHUNG
Emerson Lane
Valley Rd
TO SCOTCH PLAINS

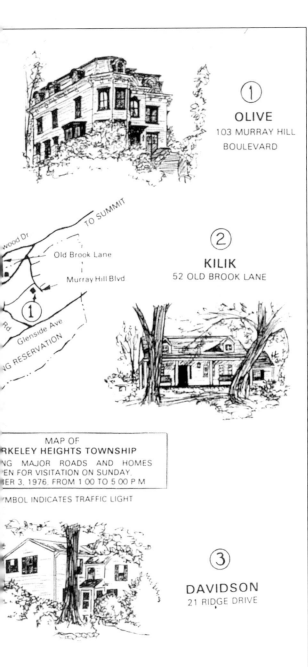

**①
OLIVE**
103 MURRAY HILL
BOULEVARD

**②
KILIK**
52 OLD BROOK LANE

MAP OF
RKELEY HEIGHTS TOWNSHIP
NG MAJOR ROADS AND HOMES
EN FOR VISITATION ON SUNDAY,
ER 3, 1976, FROM 1 00 TO 5 00 P M

MBOL INDICATES TRAFFIC LIGHT

**③
DAVIDSON**
21 RIDGE DRIVE

A BICENTENNIAL MAP, 1976.
One of the many township events celebrating the nation's bicentennial was a Heritage Day tour of the historically significant homes on this map. Under the leadership of the Union County Cultural and Heritage Commission, Berkeley Heights joined the Bicentennial Organization on March 8, 1973, with Katharine Clay Williams and Salvatore Del Duca serving as the township's representatives. On February 21, 1974, Berkeley Heights was named a bicentennial community, the 12th so designated in the state and the second in Union County. That September, a bicentennial flag was presented to the township at a ceremony in town hall. Other special bicentennial activities included a motto and logo contest, an antique doll show, a costume parade, art shows, and additional Heritage Days. Around that time, the Berkeley Heights Historical Society compiled a township history entitled *From the Passaiack to the Wach Unks*. (Berkeley Heights Historical Society.)

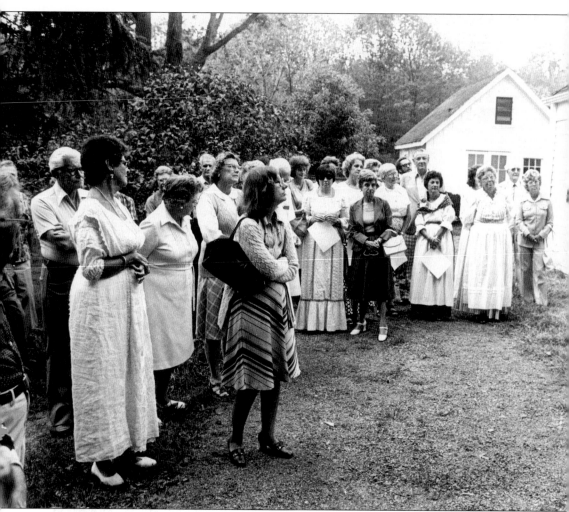

A HISTORIC OPENING, SEPTEMBER 1980. The Littell-Lord Farmstead museum (31 Horseshoe Road), owned by the township and restored by the Berkeley Heights Historical Society, officially opened for visitors on September 7, 1980. Among those pictured at the opening are Katharine Clay Williams, wife of former mayor Thomas J. Williams; Lucy Ralston, wife of mayor James V. Ralston; Karin Miller, wife of deputy mayor Robert Miller; Marie D'Innocenzio and Marie Bosco, members of the restoration planning committee; Ann Bouknight, Catharine Black, and Ethel Gilroy, members of the Questers organization that furnished the farmhouse kitchen; Bertha "Bertie" Weil, who prepared flower arrangements and refreshments; and Frank Orleans, president of the New Providence Historical Society. The farmhouse is believed to have been built by weaver Andrew Littell in the mid-1700s. The Lord family acquired the farmstead in 1867 and lived there until the Township of Berkeley Heights purchased the property in 1975. The historical society has restored the house, which serves as a living museum dedicated to local history. Outbuildings on the 18-acre property include a summer kitchen, springhouse, and corncrib. The entire property is listed on the National Register of Historic Places, and on the state register as well. (Berkeley Heights Historical Society.)

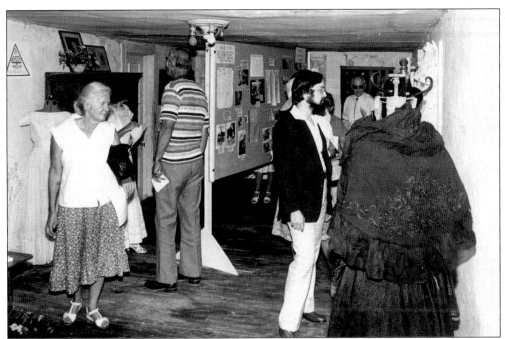

MUSEUM EXHIBITS, SEPTEMBER 7, 1980. A group studies the displays in the meeting room on the opening day of the Littell-Lord Farmstead museum. From left to right are visitor Anne Snyder, Carole Howe of Questers, recreation commissioner Ted Nelson, and historical society member Donald Davidson. This room, the lean-to kitchen, a main room with a corner fireplace, and a small adjoining room made up the original house. (Berkeley Heights Historical Society.)

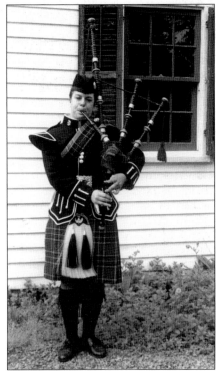

THE PARLOR OPENING CEREMONY, MAY 17, 1992. Highlander Band piper Susanne Bovine officially announces the opening of the newly redecorated Victorian parlor at the Littell-Lord Farmstead and entertains visitors at the festivities. (Berkeley Heights Historical Society.)

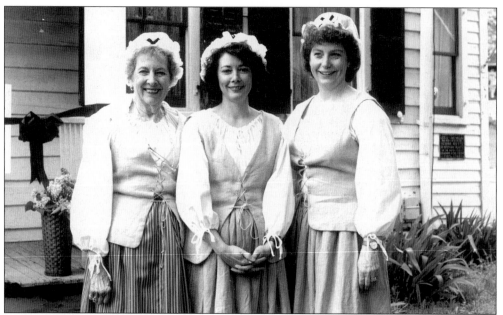

DOCENTS FOR THE PARLOR OPENING, MAY 17, 1992. Doris Grow (left), Susan Golden (center), and Pam Bowman are ready to usher visitors into the Victorian parlor of the Littell-Lord Farmstead and relate its history. The parlor is located in the front of the farmhouse, and historians believe that it was added soon after the Lord family purchased the property in 1867. (Berkeley Heights Historical Society.)

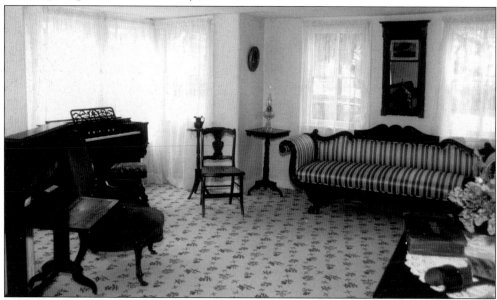

THE PARLOR, MAY 17, 1992. When the Berkeley Heights Historical Society decided to restore this room, it commissioned the Springfield firm Design for Interiors to help. Since the Lord family would have brought some favorite pieces with them to their new home and purchased others after they moved into the house, the society decided to restore the parlor to the 1840–1880 period. At an earlier time, the middle wall of the room was removed, making one large parlor out of two rooms. (Berkeley Heights Historical Society.)

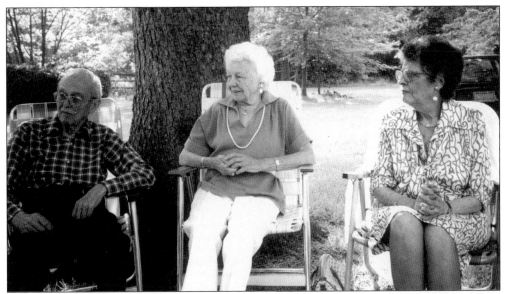

HISTORICAL SOCIETY PICNICKERS, JUNE 1992. Jim Throckmorton (left), Mary Finley (center), and Katharine Clay Williams—all active members and trustees of the society—enjoy a peaceful June day on the grounds of the Littell-Lord Farmstead. The Berkeley Heights Historical Society is a private, nonprofit corporation, founded to encourage the preservation of local history from the time of the early settlers in the 1770s to the present. Merrill Main and Daniel Palladino now serve as co-presidents of the society, succeeding longtime president Helen Tyler. (Berkeley Heights Historical Society.)

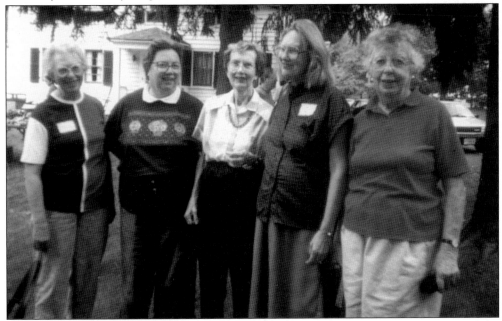

A HISTORICAL SOCIETY SALE, SEPTEMBER 20, 1997. A group gathers on the lawn of the Littell-Lord Farmstead while attending the society's garage, antiques, and collectibles sale. From left to right are Barbara Preston Little, historical society president Helen Tyler, Helen Whitcomb, Grace Hagedorn, and Betty Moran. (Joan L. Rotondi.)

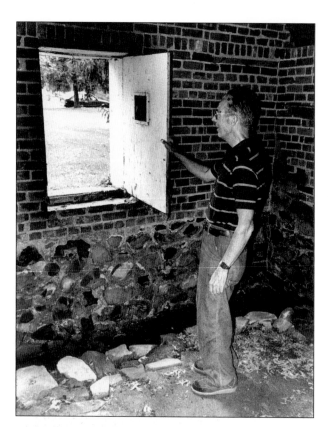

THE SPRINGHOUSE, SEPTEMBER 23, 1986. Former township historian Fred S. Best explains that this brick-and-stone springhouse on the Littell-Lord property was used before the days of refrigeration to store perishables and may have been built prior to the Lord family's arrival in 1867. It is the only existing springhouse in Union County. (Berkeley Heights Historical Society.)

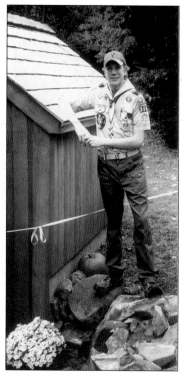

THE NEW SPRING SHED DEDICATION, OCTOBER 17, 2004. Alex Thew, a Boy Scout from Troop 368, stands proudly by the new spring shed that he planned and built with help from other Scouts, fathers, and Rocco Mazza, a local resident who donated many hours to the project. Alex asked Daniel Palladino of the Berkeley Heights Historical Society for help in finding a suitable project for his Eagle Scout badge. Since the old shed needed much repair, a new spring shed became the perfect solution. The shed covers a natural spring that flows into the springhouse and out into the adjacent brook and pond. (Virginia B. Troeger.)

Six
A Photographer's Journey

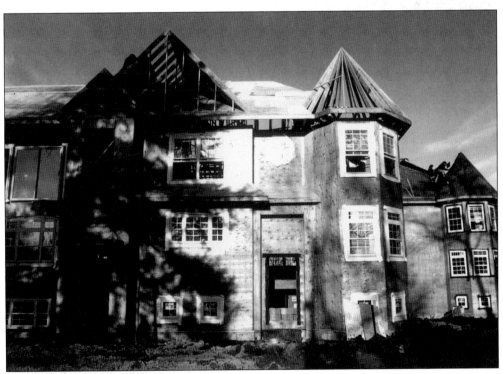

JANUARY 29, 1995. This image shows construction of new condominiums in progress on Plainfield Avenue, across from Memorial Field. In 1995 and 1996, longtime township resident Joan L. Rotondi, who later moved to Pennsylvania, took a photograph every day in Berkeley Heights. Her discerning eye for often-unnoticed details and her obvious love for the townsfolk of all ages are evident in this collection highlighting the more than 700 photographs she took during that two-year period.

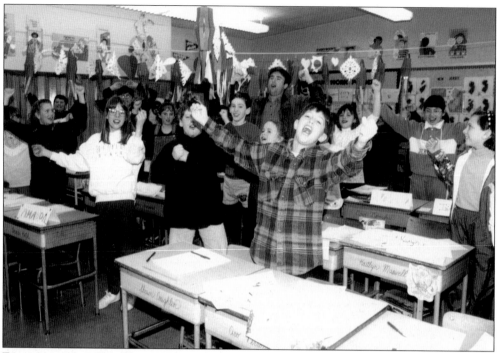

FEBRUARY 14, 1995. This poetry workshop was held in Sherry Butler's fourth-grade class at Mountain Park School.

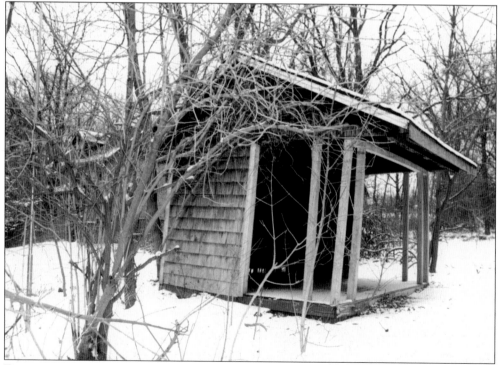

FEBRUARY 26, 1995. The Stony Hill bus stop on Sycamore Avenue near Mountain Avenue was later razed for new home construction.

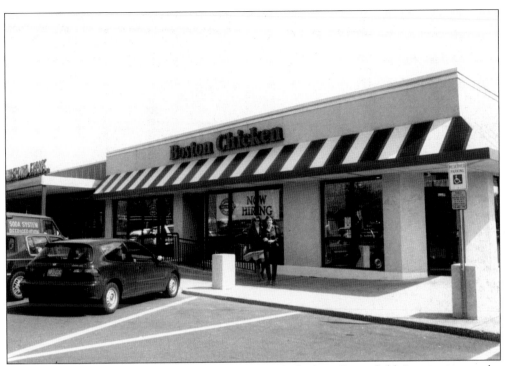

MARCH 20, 1995. Boston Chicken (later Boston Market) on Springfield Avenue is now the site of Dunkin' Donuts.

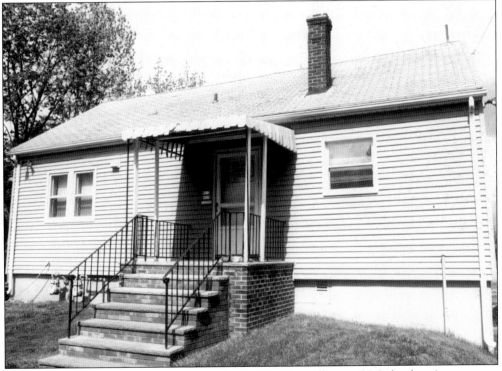

APRIL 30, 1995. Seen here is the recreation commission office, at 56 Columbus Avenue.

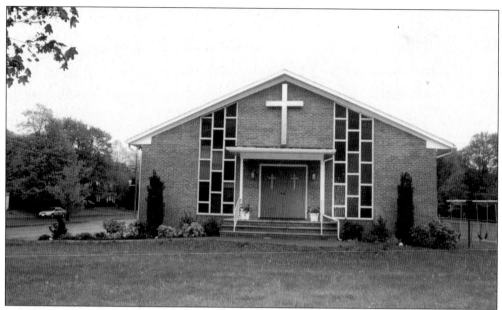

MAY 10, 1995. The Faith Chapel (Assembly of God) stands at 172 Springfield Avenue, on the corner of Lawrence Avenue.

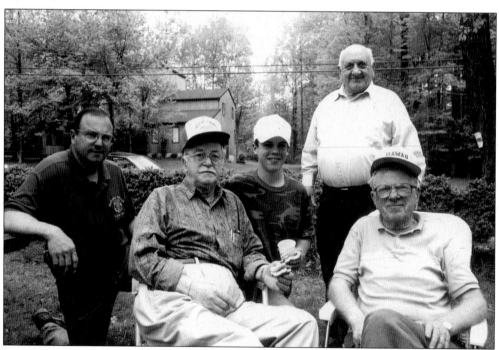

MAY 13, 1995. Policemen's Benevolent Association fishing derby attendees include, from left to right, Mickey Monica, James Monica with grandson Jimmy Monica, Daniel Palladino Sr. (standing), and Bob Quirk Sr.

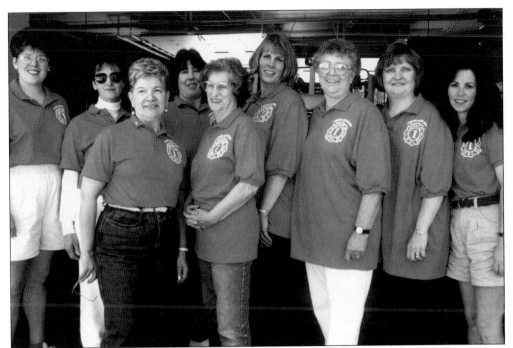

MAY 20, 1995. The ladies' auxiliary of the Berkeley Heights Volunteer Fire Department holds an annual plant sale. From left to right are Leslie Boss, Pauline Scholl, Anne Manganelli, Maria Schaumberg, Lillian Masullo, Mary Giacco, Carol Imbimbo, Carolyn Kocis, and Kathy Amiano.

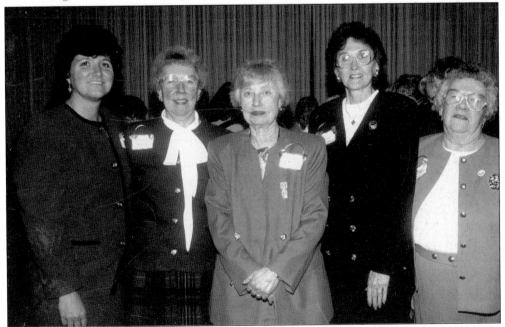

MAY 21, 1995. This photograph was taken at the 40th-anniversary celebration of the Berkeley Heights Woman's Club. From left to right are township mayor Jeanne P. Viscito, Doris Sievering, and president Rebecca Brown of the Berkeley Heights Woman's Club. (The other two women are the president and a representative of the General Federation of Woman's Clubs of New Jersey).

JUNE 7, 1995. Crossing guard Dorothy Siksnius is on duty at Columbia School on Plainfield Avenue.

JUNE 18, 1995. The familiar New Jersey Transit railroad station was painted red when this photograph was taken.

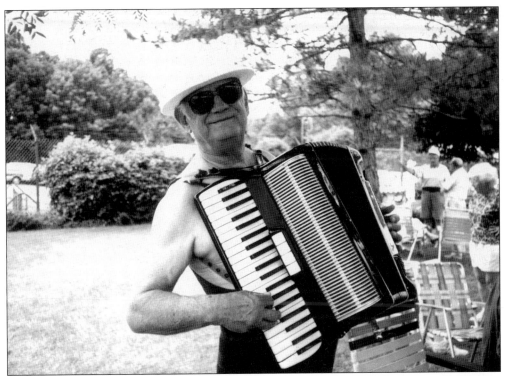

JULY 11, 1995. "Music man" Al Boyance entertains at a senior citizens' picnic in the park.

JULY 13, 1995. Seen here is Mildred Venezia, a resident at Runnells Specialized Hospital and Rehabilitation Center, on Watchung Way.

AUGUST 13, 1995. This corncrib is located on the Littell-Lord Farmstead on Horseshoe Road.

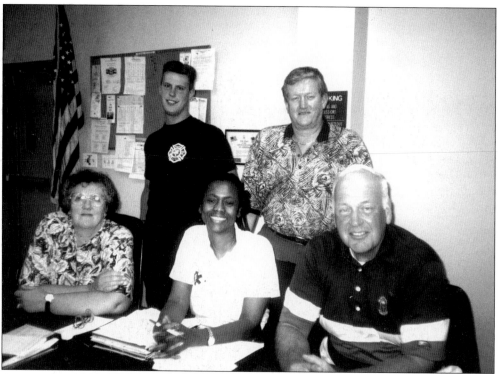

AUGUST 22, 1995. These rescue squad members are, from left to right, Mary Lou Kirtland, an unidentified volunteer, Sally Starks, Al Grorude, and Art Lundgren.

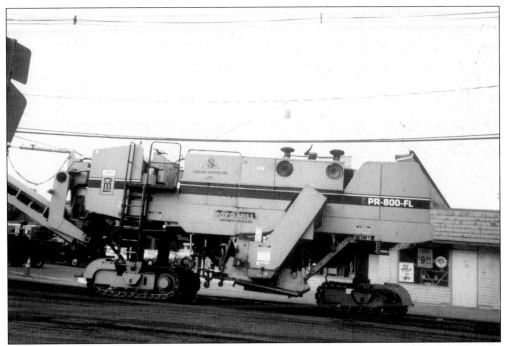

AUGUST 31, 1995. Repaving work proceeds on Plainfield Avenue.

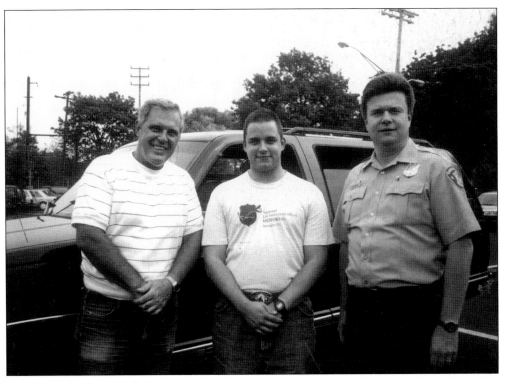

SEPTEMBER 13, 1995. Police captain Mike Borsos (left) poses with police dispatchers John Donohue (center) and Bob Quirk Jr. outside the police station on Park Avenue.

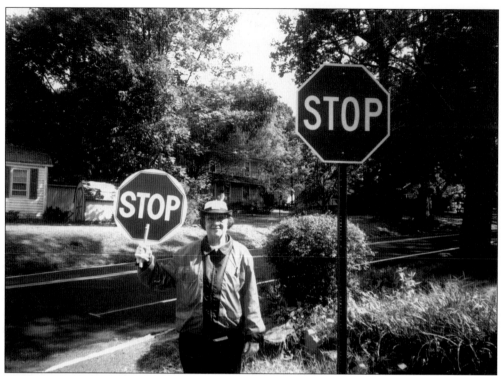

SEPTEMBER 15, 1995. Crossing guard Ann Neale is at her post on Plainfield Avenue near Rogers Avenue.

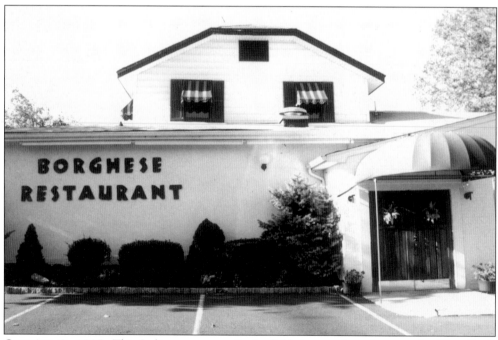

OCTOBER 9, 1995. This Italian eatery on Springfield Avenue later became the Trap Rock Restaurant and Brewery.

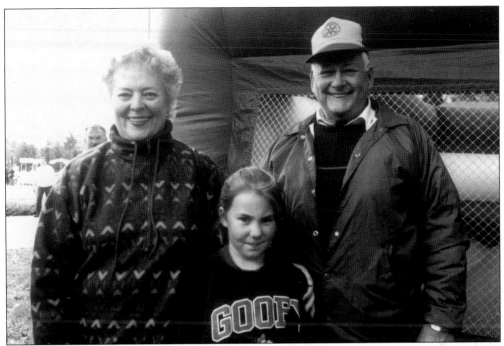

OCTOBER 15, 1995. Jane and Steve Ignaut are pictured with their granddaughter at the township Fun Fest at Memorial Field.

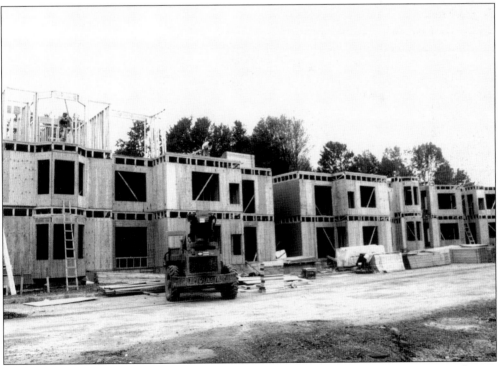

OCTOBER 1, 1995. New residential construction is under way next to Kings Super Market on Sherman Avenue.

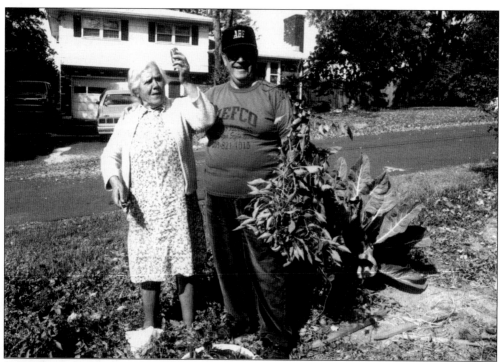

OCTOBER 19, 1995. Gardeners Carmela Del Duca and Frank Delia display their prize peppers.

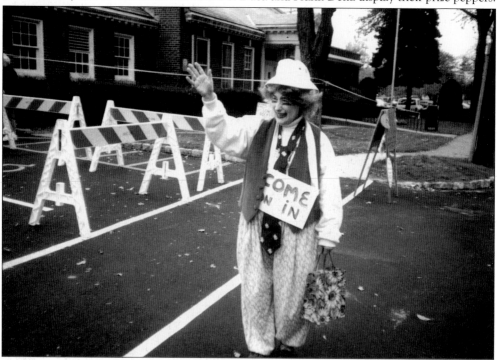

OCTOBER 21, 1995. This jolly clown (Carol Taylor) outside the Community Center on Park Avenue is publicizing the fourth annual craft fair to benefit the homeless and poor of Union County, sponsored by the Friends of St. Joseph Social Service Committee of Berkeley Heights.

NOVEMBER 9, 1995. This apartment and storage building stands next to Berkeley Hardware on Springfield Avenue. The site was once the location of the Berkeley Bakery, a popular shop for many years.

NOVEMBER 12, 1995. The Springfield Avenue drugstore Liss Pharmacy closed in 2004.

November 27, 1995. Nativity figures, handmade and painted by Anne and Frank Bosefskie in 1955, are on display in front of the Bosefskie home.

December 1, 1995. Posing for a picture are longtime Free Acres residents Zelda Benjamin (left), wife of artist Gershon Benjamin, and Dr. Fanny Stoll, mother of Laurel Hessing, also of Free Acres.

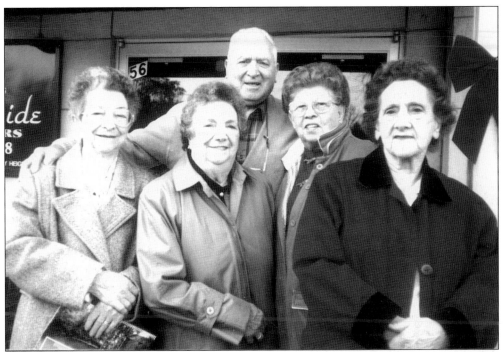

DECEMBER 5, 1995. These senior citizens standing outside Mount Carmel Hall are, from left to right, Josephine Yannotta, Anna Amodeo, Matt Fornaro, Laura Teste, and Mildred Monsipapa.

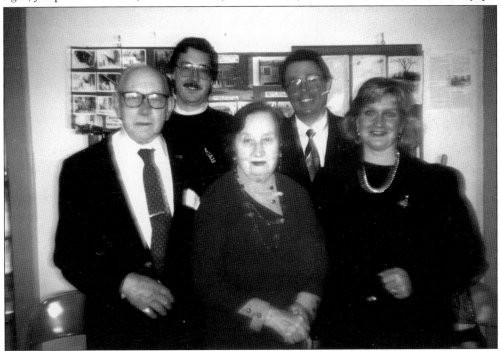

DECEMBER 10, 1995. From left to right are Barnaby, Sergei, and Ludmilla Kent, with Tom and Georgene Granholm at the Berkeley Heights Historical Society's Christmas party, held in the Littell-Lord Farmstead.

DECEMBER 15, 1995. Greg Granholm is shown with his nutcracker display at the public library.

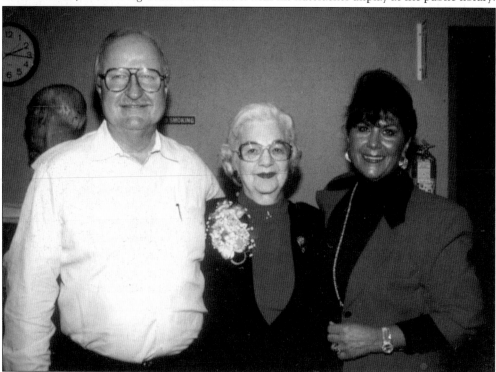

JANUARY 19, 1996. Bob Tokash, Frances Truppi (center) and her daughter Nadine Tokash are pictured on the occasion of Frances's retirement from Runnells Specialized Hospital.

118

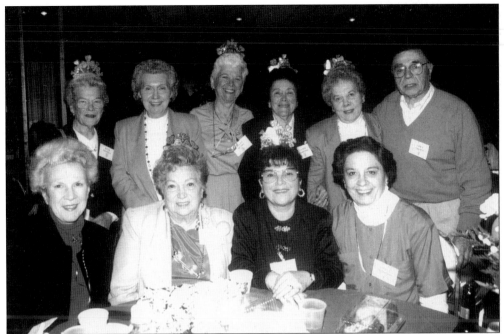

MARCH 1996. St. Patrick's Day celebrants attend a party for senior citizens. From left to right are the following: (first row) Janet Prince, Kathleen Candela, Kathleen Parziale, and Grace Hodshon; (second row) Ruth Merrill, Dorothy Fornaro, Helen Russo, Catherine Martino, Josephine Groppi, and Vincent Groppi.

MARCH 31, 1996. Rev. John McGovern, pastor of Little Flower Church, displays a palm cross made by Vito Mondelli.

APRIL 5, 1996. Longtime residents Nean and Mary Lund of Orchard Lane pose for a picture.

APRIL 8, 1996. Township employees John Mineo (left) and Rocco Mazza update the community events sign on Springfield Avenue.

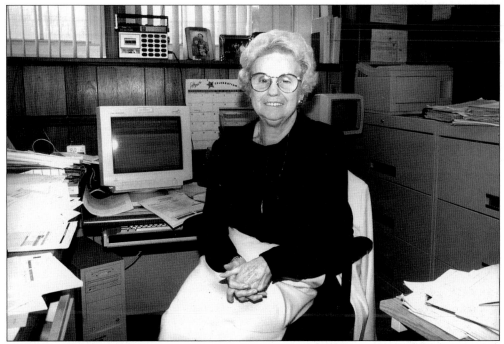

APRIL 17, 1996. Edna Duffy served as administrative assistant to several township superintendents of schools, including Dr. Ehrling W. Clausen and Dr. Robert T. Stowell.

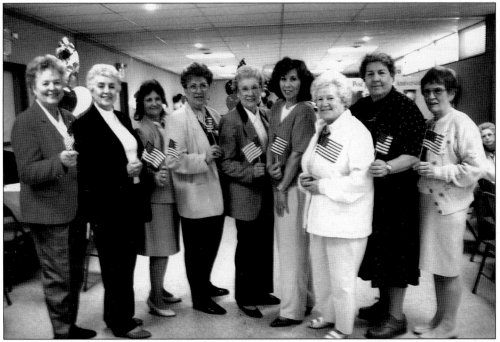

APRIL 27, 1996. Members of the ladies' auxiliary of the Veterans of Foreign Wars gather on the occasion of the group's 50th anniversary. From left to right are Jane Ignaut, Alice Keimel, unidentified, Rose Dagostino, Doris Rupprecht, Roseanne Mazur, Sally Cadmus, Josephine Kukis, and Jean Schaefer.

MAY 13, 1996. This sign on a front lawn urges a yes vote for the deregionalization of the Union County Regional High School District No. 1.

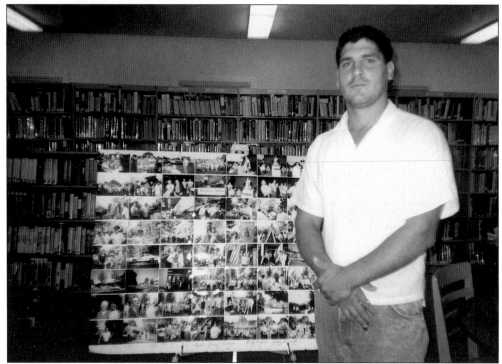

JULY 25, 1996. In the public library, the president of the Mount Carmel Society, Louis DiPasquale, stands with a display of photographs of the Mount Carmel Fair.

122

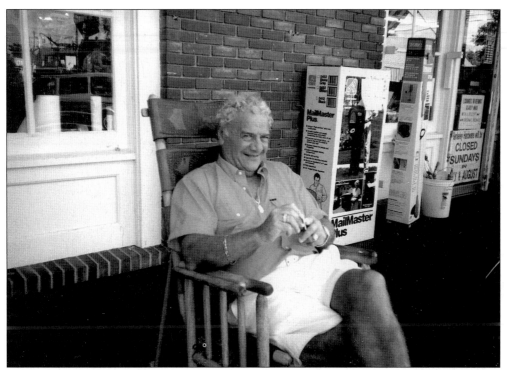

AUGUST 10, 1996. Chuck Vicendese poses at Berkeley Hardware.

AUGUST 23, 1996. Seen here are the railroad crossing gates at Snyder Avenue.

AUGUST 28, 1996. Storefronts next to Drug Fair, on Springfield Avenue, await the arrival of the Fuji Japanese and Siam Village Chinese and Thai restaurants.

AUGUST 27, 1996. This tree-shaded house stands on Passaic Avenue.

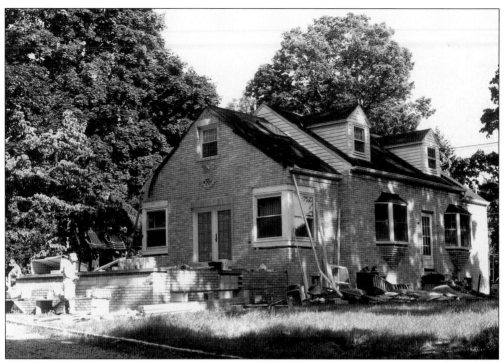

AUGUST 30, 1996. Home improvements are under way on Debbie Place.

SEPTEMBER 5, 1996. Emily Conforto is ready for her first day of kindergarten at Mountain Park School.

OCTOBER 31, 1996. Halloween celebrants gather at town hall. From left to right are Arlene Lowe, Barbara Healy, township clerk Trudy Gonnelli, deputy clerk Melissa Palfy, and Michelle Wendlend.

NOVEMBER 4, 1996. Hope Danzis, former president of the Berkeley Heights Public Library's board of trustees, is pictured in front of town hall.

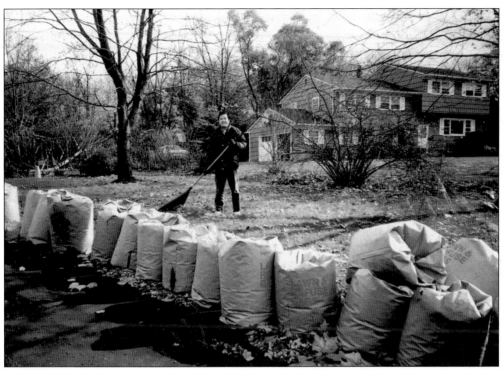

NOVEMBER 10, 1996. Benjamin Lay of Franklin Court finishes his fall leaf cleanup.

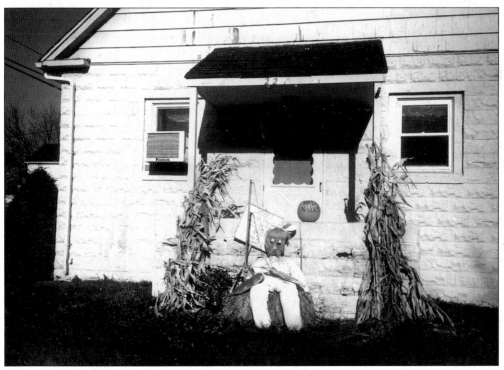

NOVEMBER 11, 1996. This Sherman Avenue home is decorated for the holidays.

NOVEMBER 12, 1996. A festive cake at town hall awaits the celebration of Trudy Gonnelli's retirement as township clerk.

BIBLIOGRAPHY

Aquillina, Charles L., Richard T. Koles, and Jean-Rae Turner. *Elizabethtown and Union County: A Pictorial History*. Norfolk, Virginia: the Donning Company, 1982.

Cunningham, John. *New Jersey: America's Cross Road*. Garden City, New York: Doubleday and Company, 1976.

Desmond, Helen E., editor. *From the Passaiack to the Wach Unks: A History of the Township of Berkeley Heights, New Jersey*. Berkeley Heights, New Jersey: Berkeley Heights Historical Society, 1977.

Fleagle, Amy. *Berkeley Heights, Beauty in the Hills* (videocassette). Avenel, New Jersey: Suburban Cablevision TV-3, 1990.

Fridlington, Robert J. *Union County Yesterday*. Larry Fuhro, illustrator. Westfield, New Jersey: Union County Cultural and Heritage Programs Advisory Board, 1981.

Goodin, Fran, and Joan L. Rotondi, producers. *Mount Carmel Festival, July 16, 1990* (videocassette). Summit, New Jersey: TV-36 Productions, 1990.

Hall, Dave. *Down by Seeley's Pond* (videocassette). Berkeley Heights, New Jersey: Davideo Multimedia Productions, 1999.

Lurie, Maxine N., and Marc Mappen, editors. *Encyclopedia of New Jersey*. New Brunswick, New Jersey: Rutgers University Press, 2004.

Rotondi, Joan L., producer. *Mount Carmel, 1974, 1975, 1976, 1979, 1995* (videocassette), 1995.

Scacciaferro, Joe, and the Berkeley Heights Education Foundation, producers. *Hello Berkeley Heights* (TV-34 program), 2004.

Smith, Thorne (1892–1934). *Topper, A Ribald Adventure*. New York: Modern Library, 1999.

Troeger, Virginia B. *Berkeley Heights*. Dover, New Hampshire: Arcadia Publishing, 1996.